Ice Cream & Sadness

Cyanide & Happiness Vol. 2

Kris, Rob, Matt & Dave

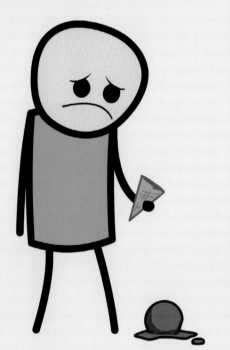

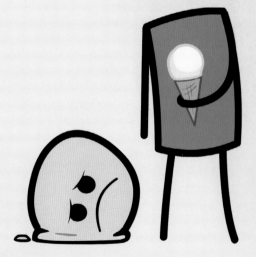

!t

itbooks

AN IMPRINT OF HARPERCOLLINS PUBLISHERS

*it***books**

An edition of this book was published in 2010 in the United Kingdom by HarperCollins.

HarperCollins books may be purchased for educational, business, or sales promotional use. For information please write: Special Markets Department, HarperCollins Publishers, 10 East 53rd Street, New York, NY 10022.

FIRST EDITION

Library of Congress Cataloging-in-Publication Data is available upon request.

ISBN 978-0-06-204622-2

12 13 14 SCP 10 9

DEDICATED TO BIFF BELVIN

We'd also like to thank Chase Suddarth for his animation wizardry, Zach Weiner for being a great booth buddy and having a sillier last name than Matt, our two fans in Congo, our one fan in Antarctica, Matt's mom for letting us say she was dead in the last book (the dead can't say no!) and of course our wonderful fans, for keeping it so damn classy.
You're kinda the best.

Foreword

Dear Reader,

Midway through the decade-we-still-don't-have-a-name-for, people thought 'webcomics' were all strips focused on video games, influenced mainly by anime and pixel art. Yet one of the most popular webcomics didn't fit that description at all, and most of my comics friends seemed to have barely heard of it. It was beloved not by comic nerds, but by real, normal people sharing comics on their eye-wateringly ugly MySpace pages. And they shared them because they were funny.

Good jokes, told well, are why Cyanide & Happiness is so popular. For a comic that packs in an awful lot of blood, stick figure nudity, abortions, and sheer contrariness, it is—at its heart—funny. The best of their strips aren't simply the ones that are the most outrageous, they're the ones that most perfectly subvert your expectations, which is what a joke should do. Sometimes that means giving you an unexpected ending to the "sitting in a tree" childhood rhyme, and sometimes it means giving you polio. But whatever the content, there's always a joke at the end.

Rob, Dave, Matt, and Kris are great guys, and their dedication to humor is complete. I've frankly got no idea what's in this book you're holding—they could've copy-and-pasted my foreword into anything—but I can confidently say that it will make you laugh. Or, failing that, it will at least distract you long enough for the guys to fuck your mom.

Randall Munroe, author of XKCD, the #1 comic on the internet

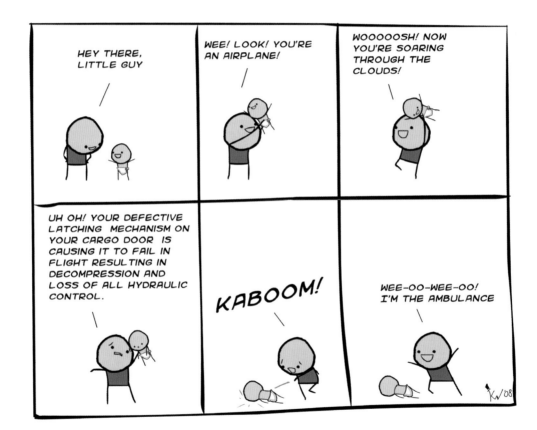

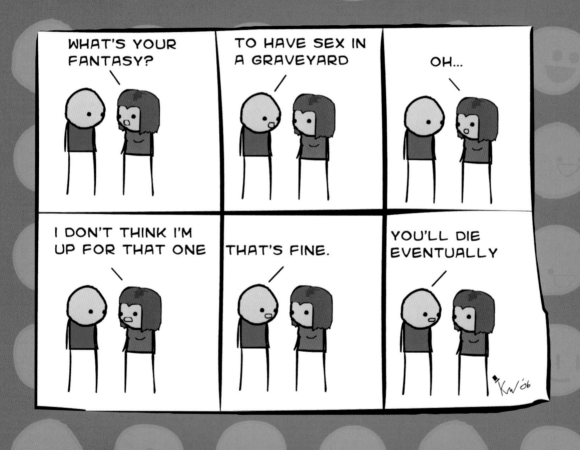

WELL, I GOT THE LAB RESULTS BACK...

YOU'VE GOT PANCREATITIS, HEPATITIS, BONE DISEASE, INTESTINAL PARASITES, SKIN CANCER, LUNG CANCER, HAIR CANCER, INGROWN RIB, ELBOW CANCER, HERPES, DYSENTERY, BROKEN PELVIS, INTERNAL BLEEDING, EXTERNAL BLEEDING, BLOOD CLOTS, SWINE FLU, SPANISH FLU, KUNG FLU, TRENCH FOOT, ATHLETE'S FOOT, ARCHER'S ELBOW, CHOLERA, FOUR BRAIN TUMORS, SEVEN KIDNEY STONES, SLEEP APNEA, AND HEART DISEASE.

AND ALSO YOU'RE DEAF.

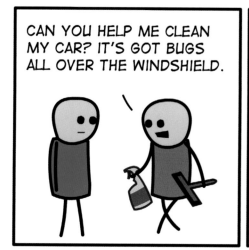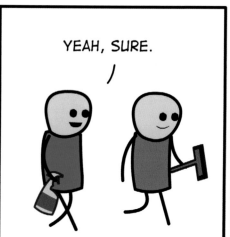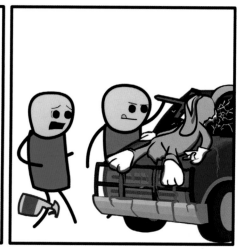

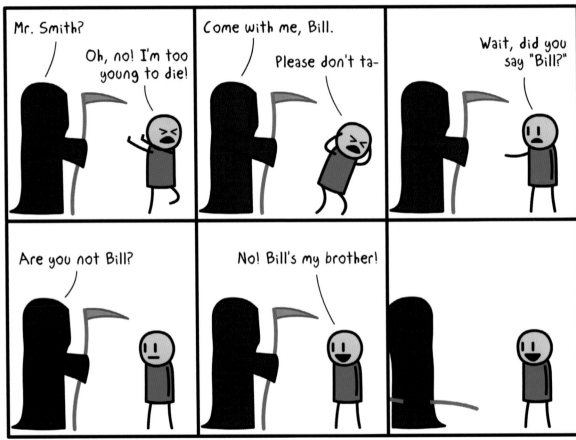

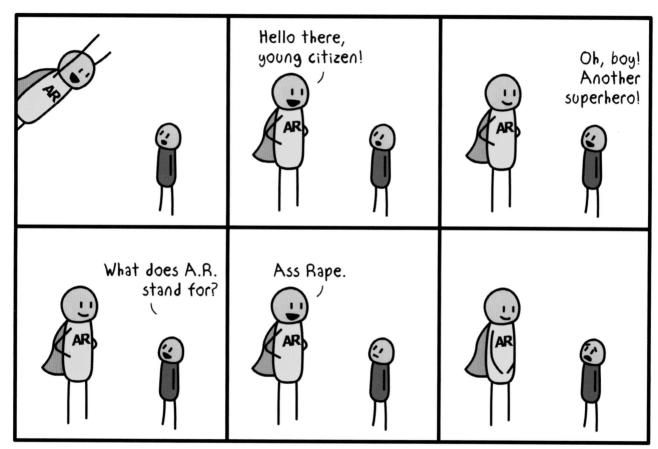

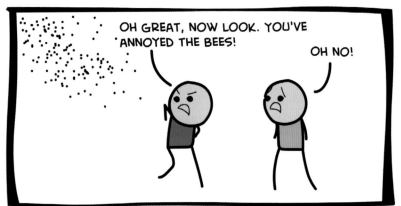

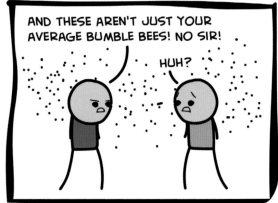

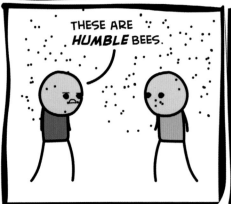

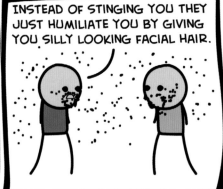

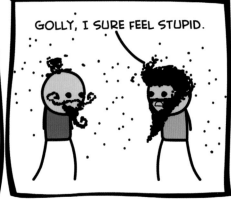

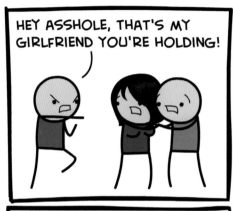

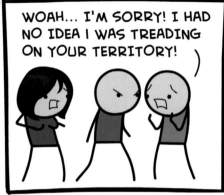

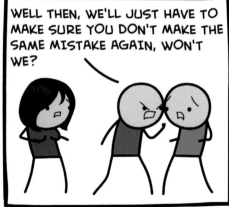

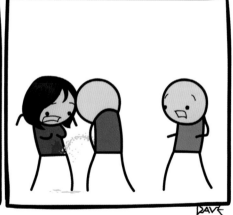

CHECK OUT THIS SWEET SCAR I GAVE MYSELF! CHICKS DIG SCARS!

HEY, BOYS! WHAT ARE YOU... **WOAH!** NICE SCAR!

WOW! THAT SURE IS A SEXY OPEN WOUND!

HEY! I LIKE YOUR SEVERED LIMB!

Doctor Baby

Season 4
Episode 17

DR. BABY, WE NEED YOU IN SURGERY FOR AN EMERGENCY QUADRUPLE BYPASS!

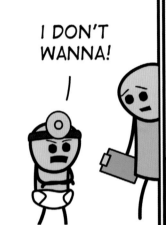

I DON'T WANNA!

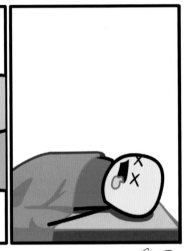

Doctor Baby

Season 4
Episode 18

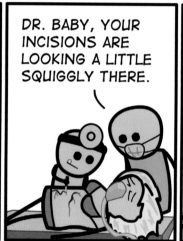

DR. BABY, YOUR INCISIONS ARE LOOKING A LITTLE SQUIGGLY THERE.

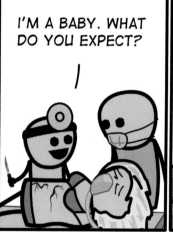

I'M A BABY. WHAT DO YOU EXPECT?

17

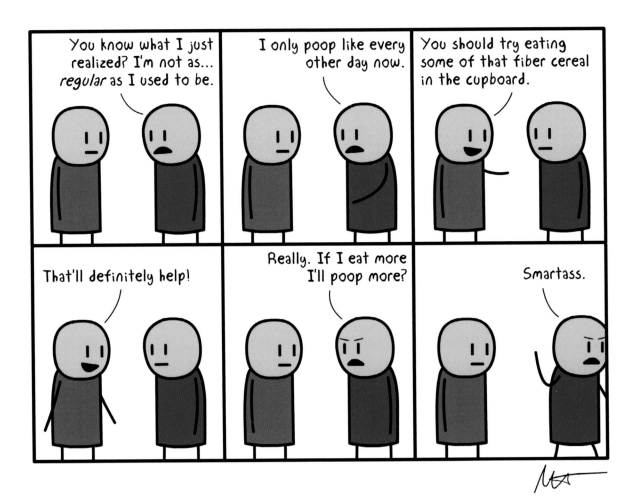

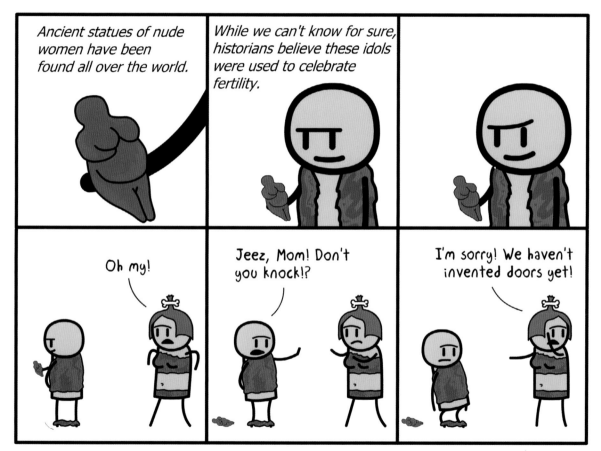

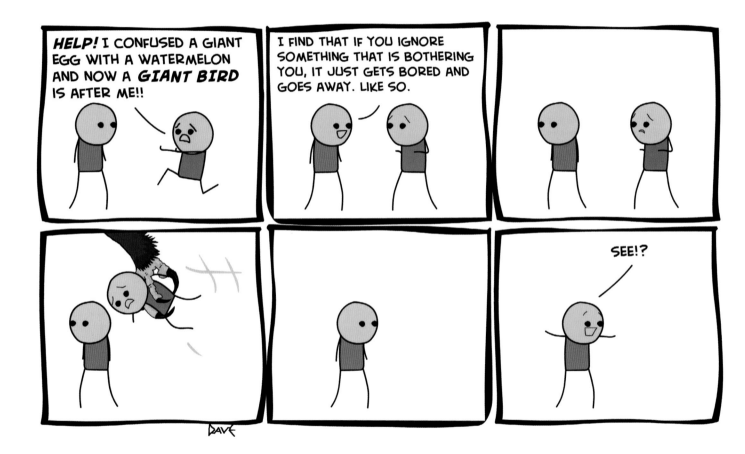

UMBILICAL CHORDS.

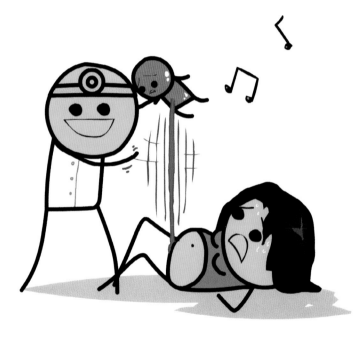

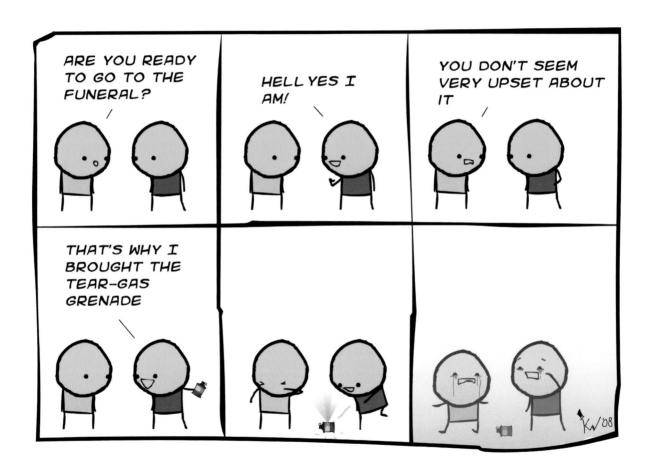

22

EVERY TIME THERE'S A KILLING SPREE, YOU SEE SOMEONE ON THE NEWS SAYING IT'S THE LAST PERSON YOU'D EXPECT TO DO THAT

KINDA MAKES YOU PARANOID, DOESN'T IT?

THAT MEANS WE'RE SAFEST AROUND PEOPLE WHO WE'D MOST EXPECT TO KILL US

LIKE THAT GUY?

AHHHHHHHHH!

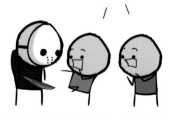

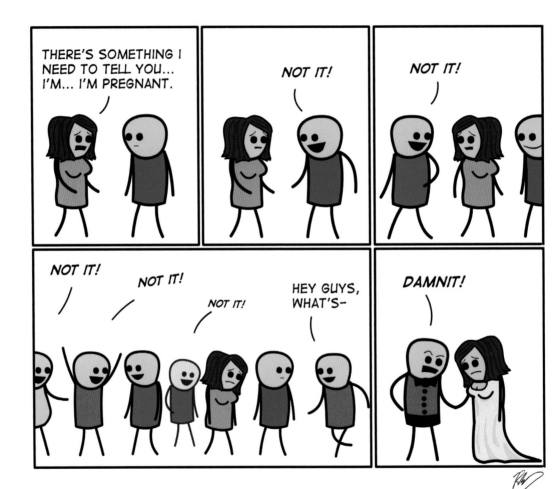

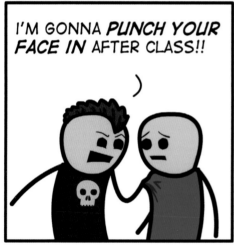

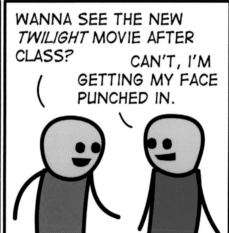

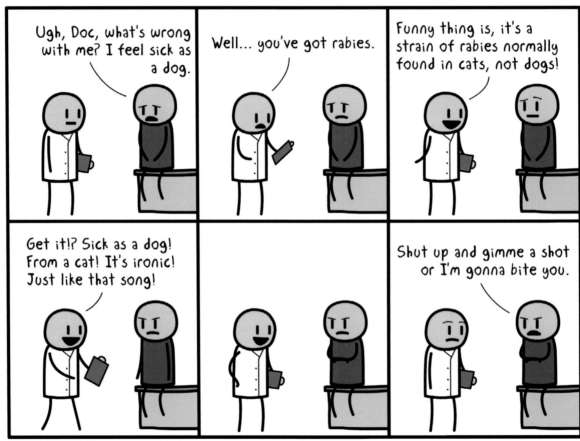

Extreme Sports Christ

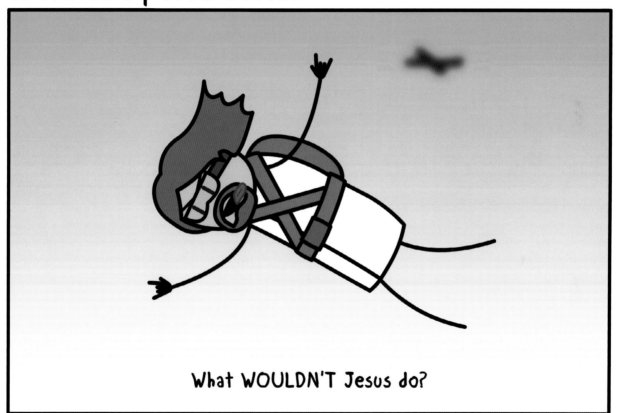

What WOULDN'T Jesus do?

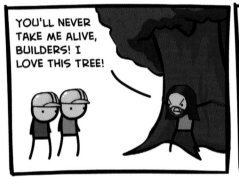

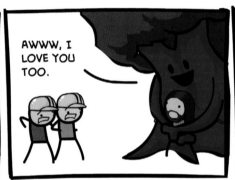

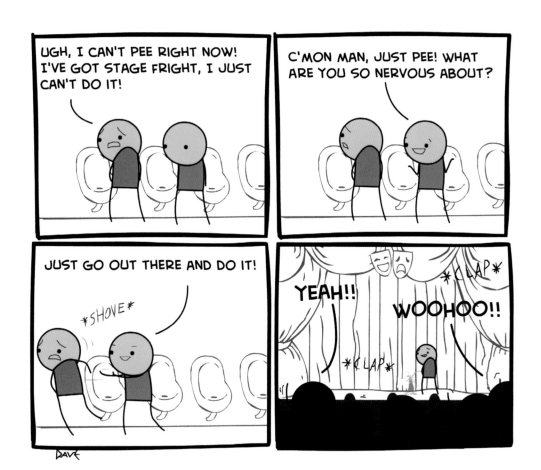

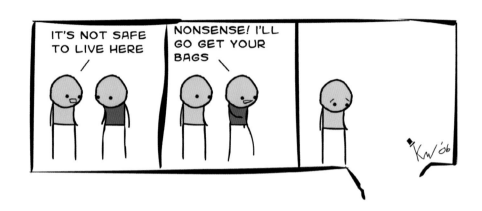

HEY, MISTER!
WILL YOU TELL
ME A STORY?

SURE, KID.

HEY DIDDLE DIDDLE,
THE CAT AND THE FIDDLE,
THE COW JUMPED OVER THE MOON!

THE LITTLE DOG LAUGHED
TO SEE SUCH SPORT,
**AND THE DISH RAN AWAY
WITH THE SPOON!**

HE RAN FROM CONVICTION
AND FED HIS ADDICTION
AS THE DISH HEATED THE SPOON.

THE SPOON BEGGED TO GO
BUT THE DISH SHOUTED **"NO!"**

"THE HEROIN WILL BE READY SOON"

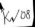

31

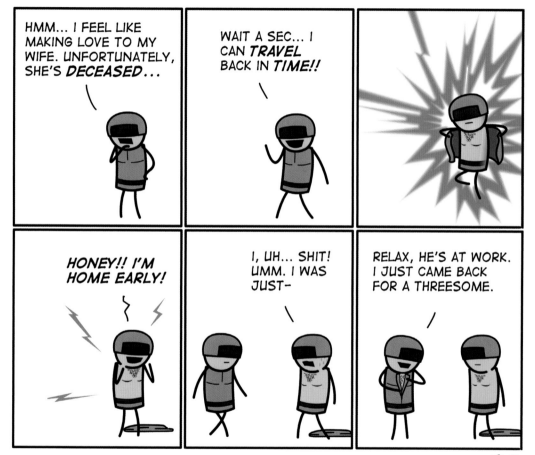

33

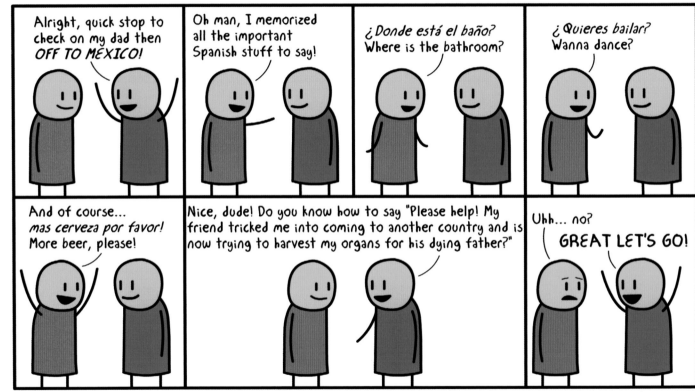

I'm a little G-spot,
Short and stout.

Here is my handle,
Here is my...

aaaahhhhhhhyeahyeah
yeahyeahoohgodohgod
godohgodohhhhgooood
ueaahhhuehhhughhghh

shudder

35

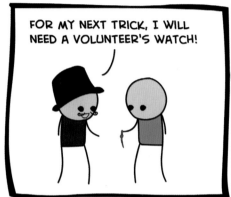

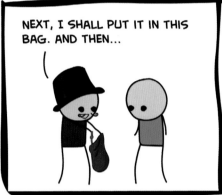

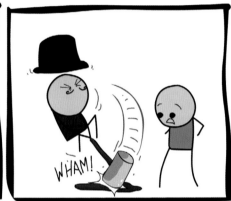

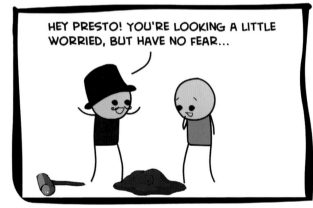

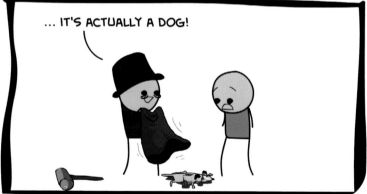

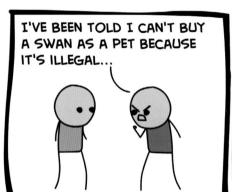

I'VE BEEN TOLD I CAN'T BUY A SWAN AS A PET BECAUSE IT'S ILLEGAL...

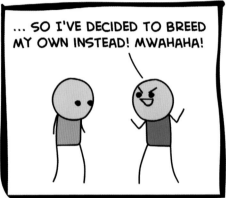

... SO I'VE DECIDED TO BREED MY OWN INSTEAD! MWAHAHA!

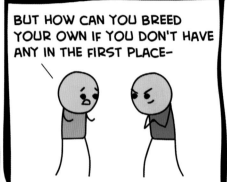

BUT HOW CAN YOU BREED YOUR OWN IF YOU DON'T HAVE ANY IN THE FIRST PLACE—

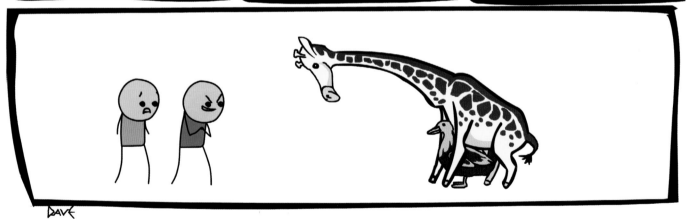

DAVE

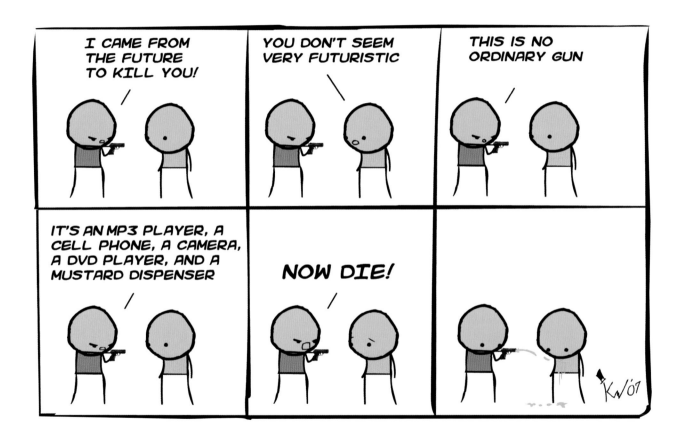

I WONDER IF DEAF SCHIZOPHRENIC PEOPLE HEAR VOICES...

I NEVER ASKED THEM

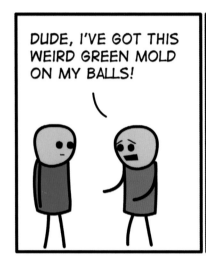

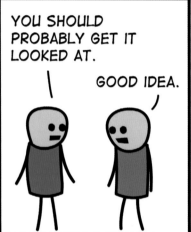

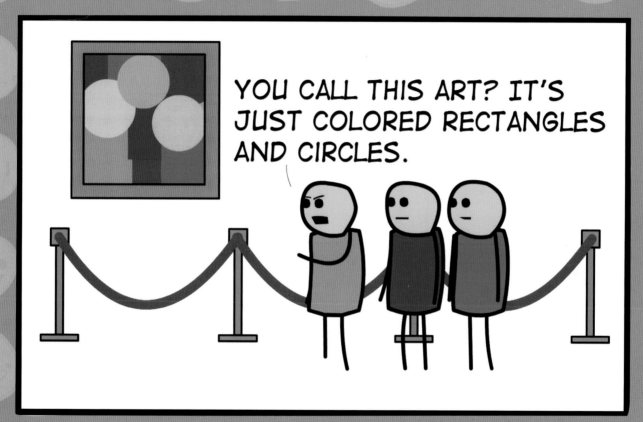

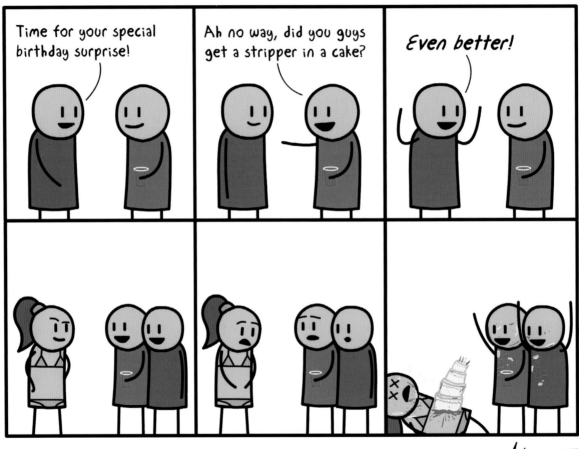

In the game of baseball, stealing third base is considered a pretty ballsy move.

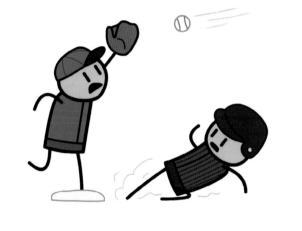

In the pursuit of love, though, stealing third base is considered sexual assault.

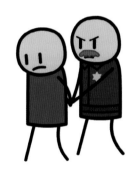

He tried to slide in on both occasions.

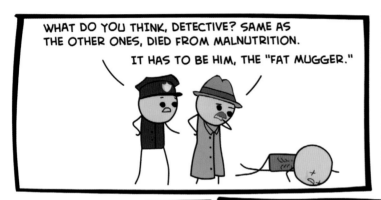

WHAT DO YOU THINK, DETECTIVE? SAME AS THE OTHER ONES, DIED FROM MALNUTRITION.

IT HAS TO BE HIM, THE "FAT MUGGER."

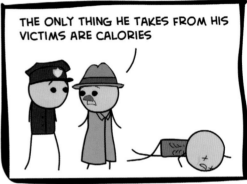

THE ONLY THING HE TAKES FROM HIS VICTIMS ARE CALORIES

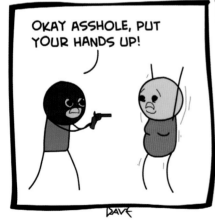

OKAY ASSHOLE, PUT YOUR HANDS UP!

DAVE

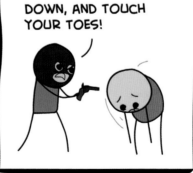

NOW PUT YOUR HANDS DOWN, AND TOUCH YOUR TOES!

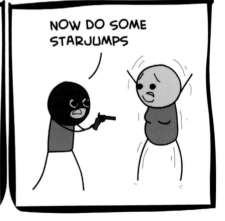

NOW DO SOME STARJUMPS

HEY KID, DID SANTA BRING YOU EVERYTHING YOU WANTED FOR CHRISTMAS?!

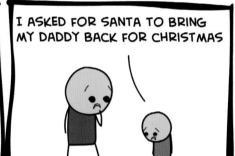

I ASKED FOR SANTA TO BRING MY DADDY BACK FOR CHRISTMAS

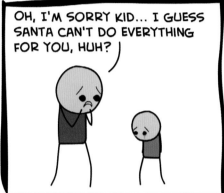

OH, I'M SORRY KID... I GUESS SANTA CAN'T DO EVERYTHING FOR YOU, HUH?

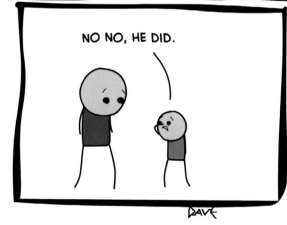

NO NO, HE DID.

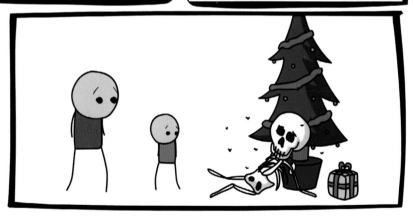

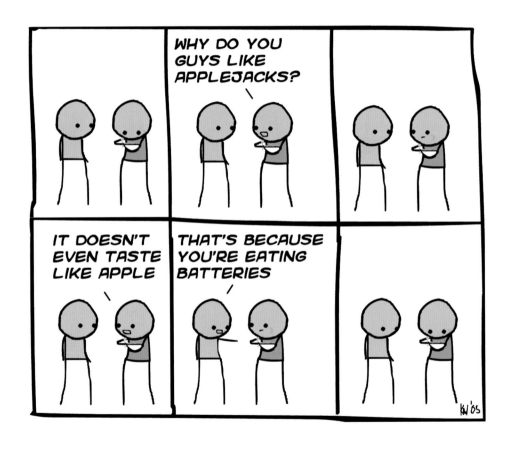

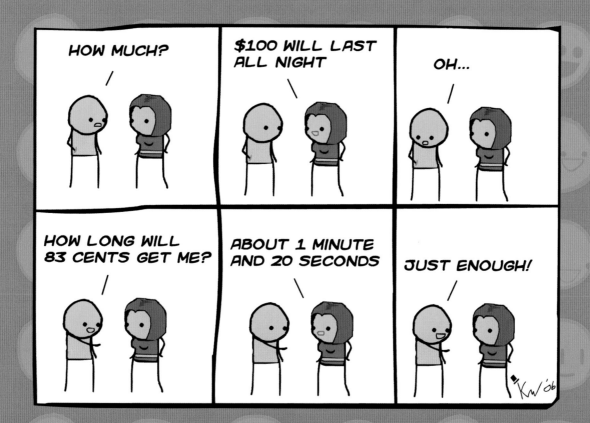

47

JOHNNY AND MARISSA, SITTING IN A TREE, K-I-S-S-I-N-G.

FIRST COMES LOVE, THEN COMES MARRIAGE.

THEN COMES AN ABRUPT, TRAGIC MISCARRIAGE.

THEN COMES BLAME, THEN COMES DESPAIR. TWO HEARTS DAMAGED BEYOND REPAIR...

JOHNNY LEAVES MARISSA, AND TAKES THE TREE.

D-I-V-O-R-C-E.

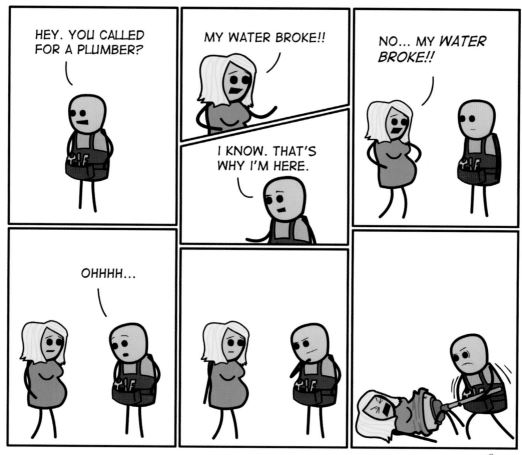

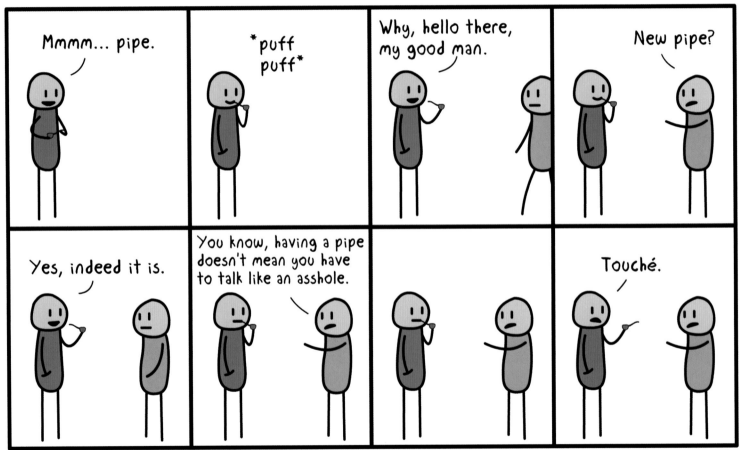

"I glide for your sins."

53

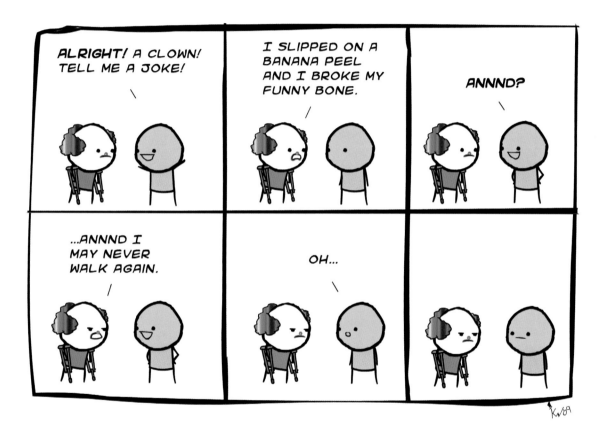

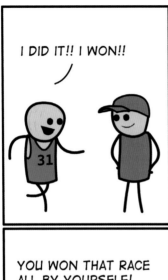

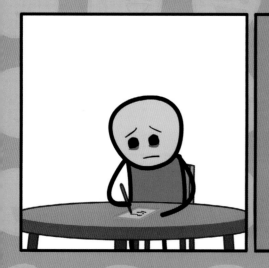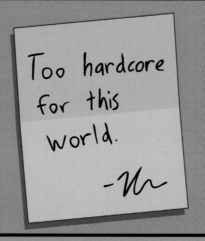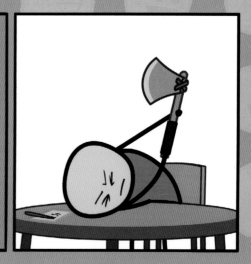

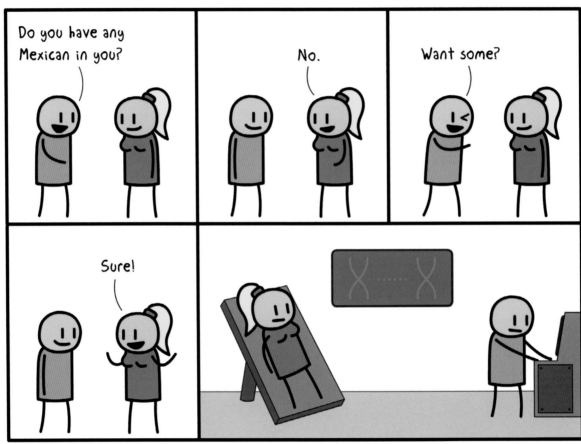

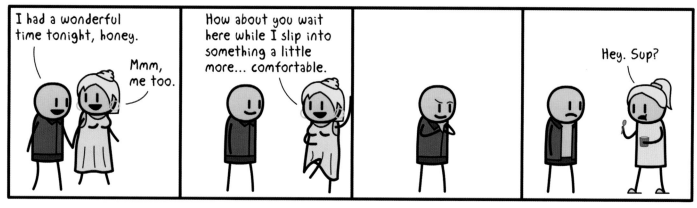

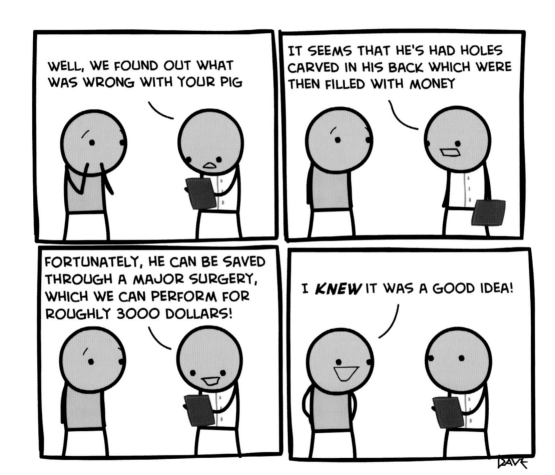

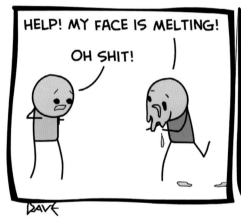
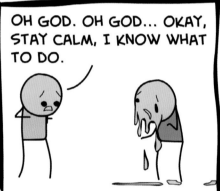
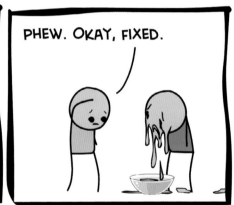

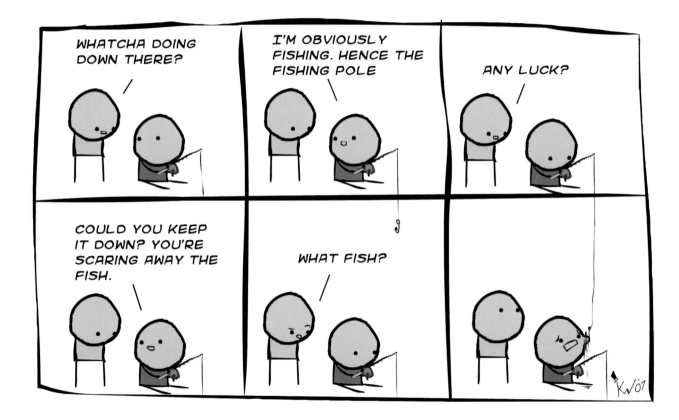

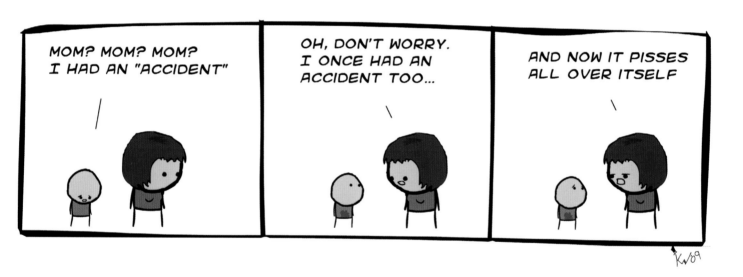

NATURE IN ACTION!

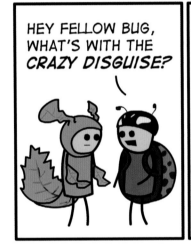

HEY FELLOW BUG, WHAT'S WITH THE *CRAZY DISGUISE?*

BY *CAMOUFLAGING* MYSELF AS A *LEAF*, I CAN AVOID NASTY PREDATORS.

BUT DON'T LOTS OF ANIMALS EAT LEAVES?

THAT'S WHY I CARRY MY JACKKNIFE.

NATURE IN ACTION!

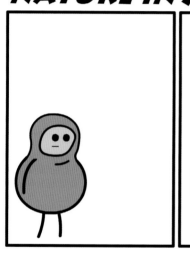
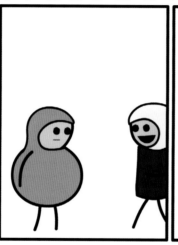
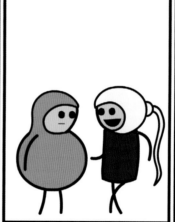

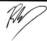

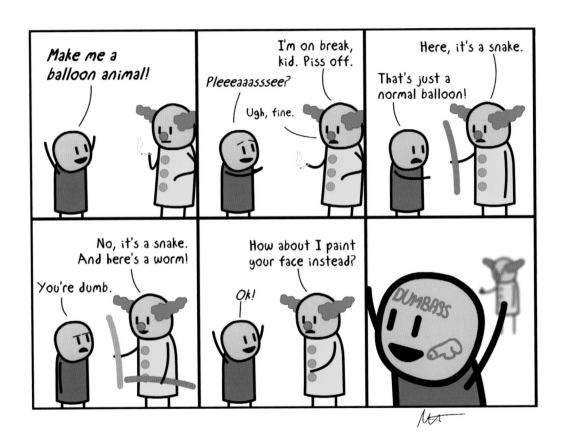

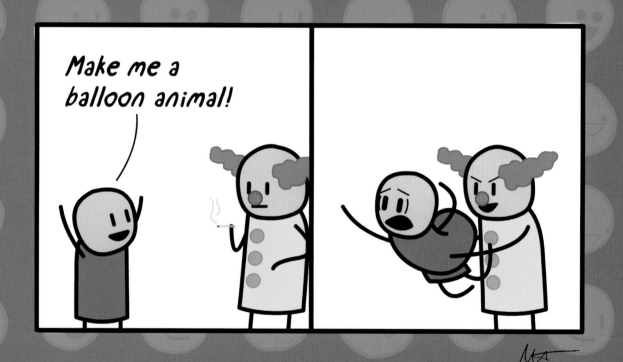

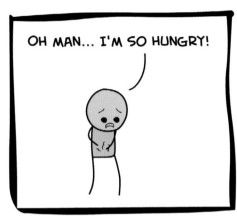

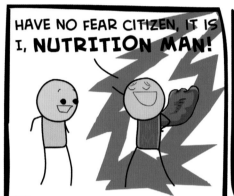

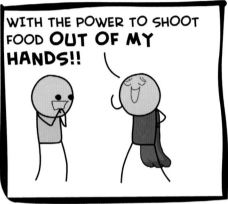

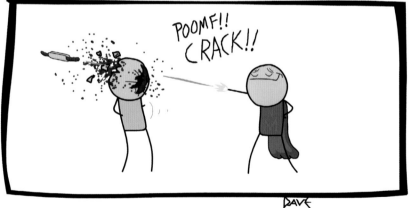

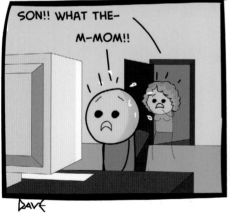
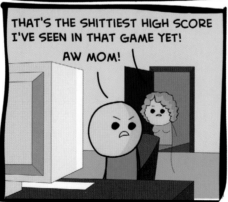
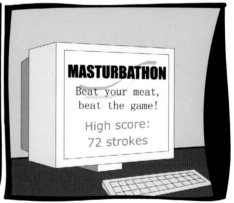

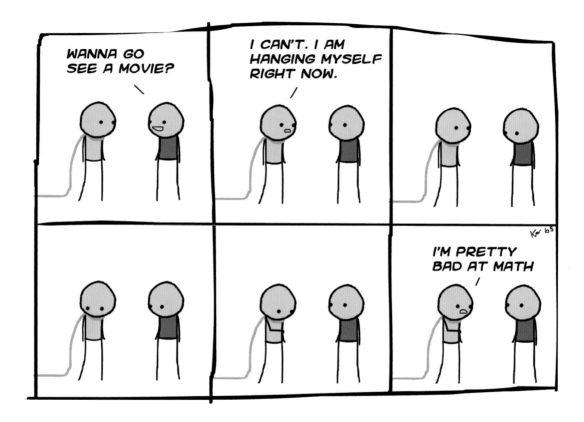

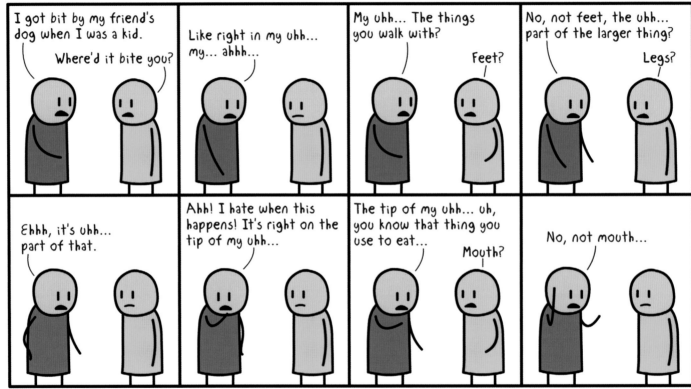

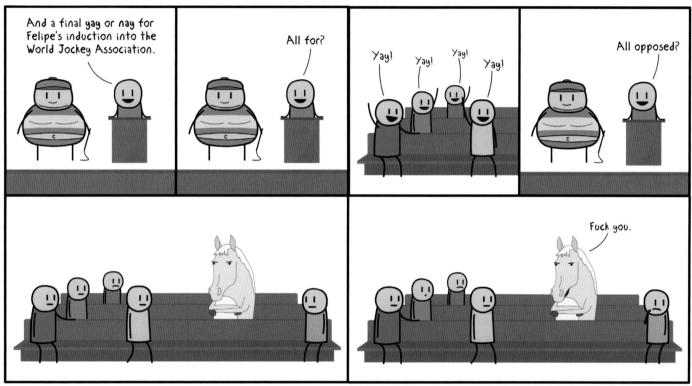

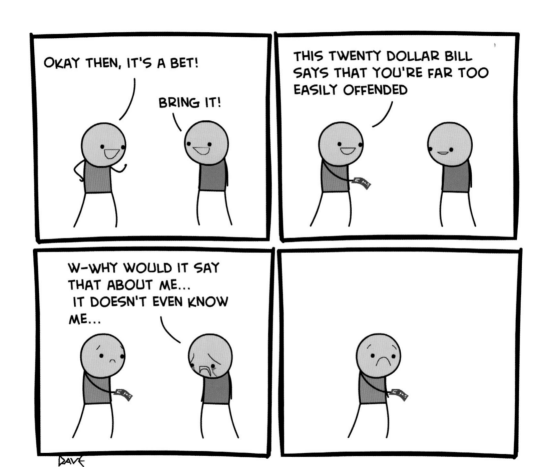

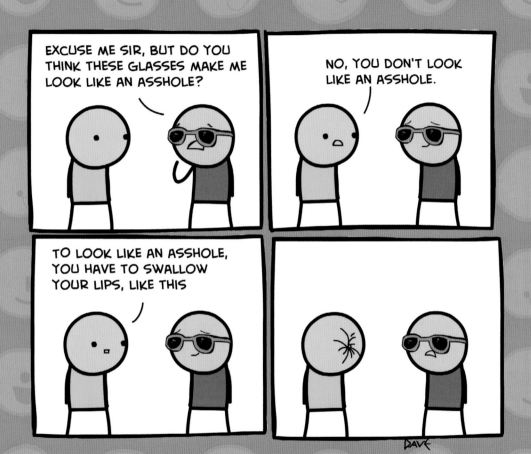

77

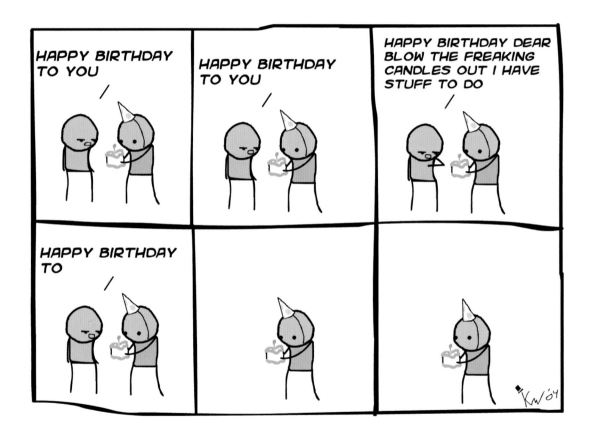

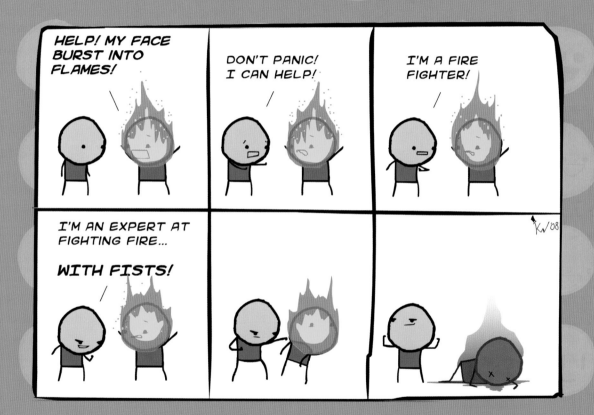

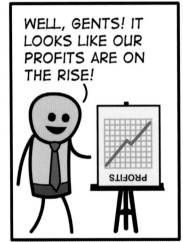

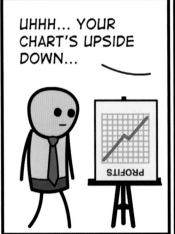

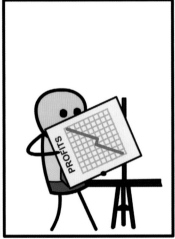

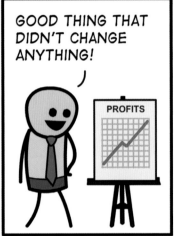

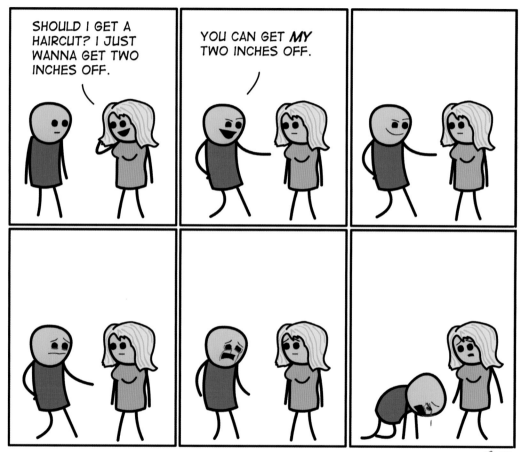

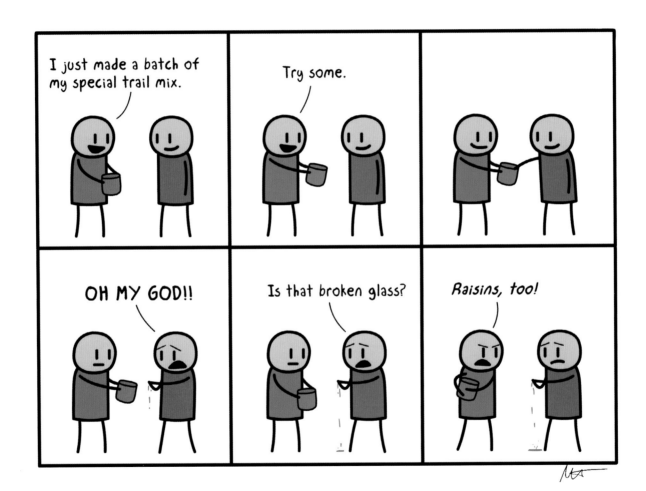

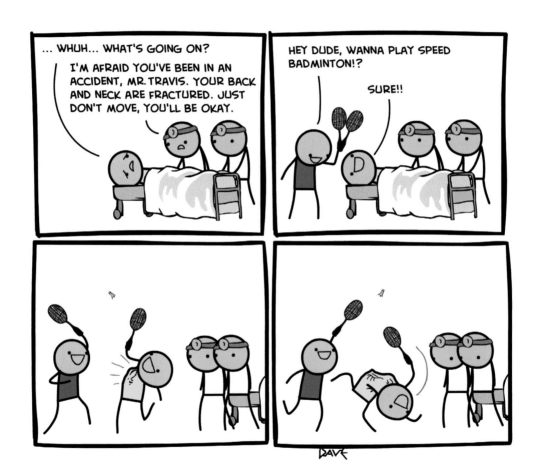

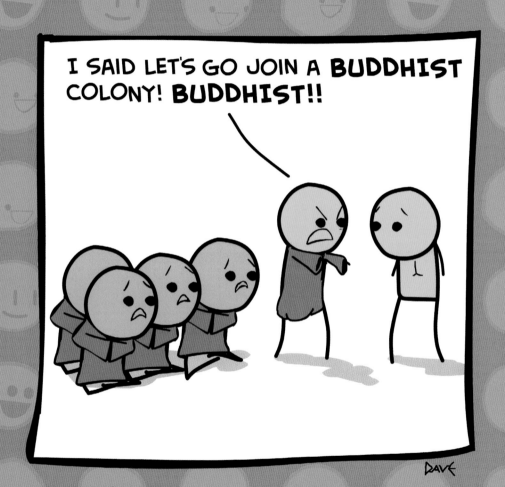

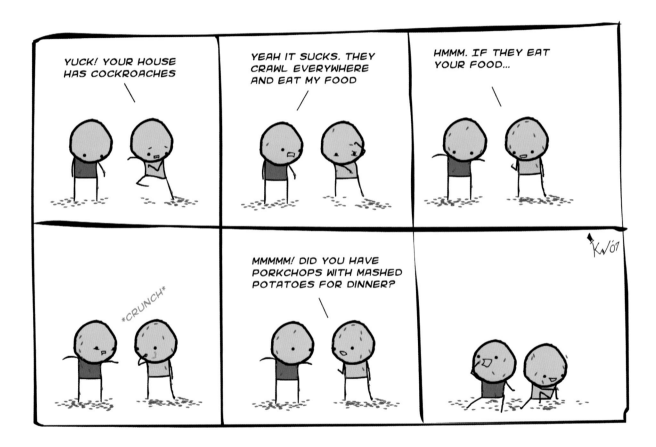

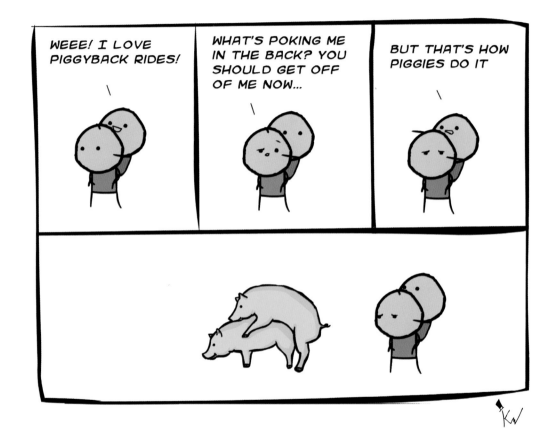

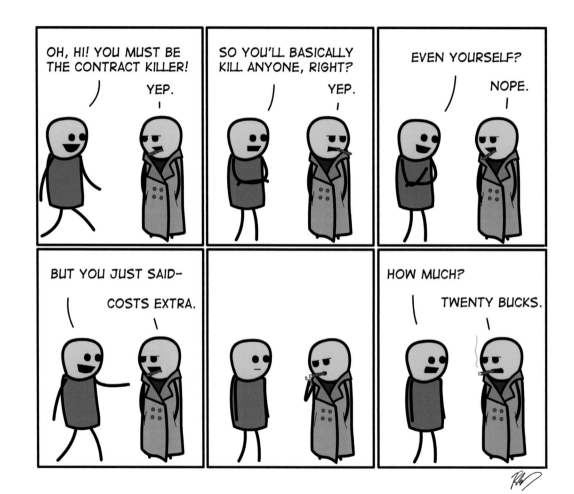

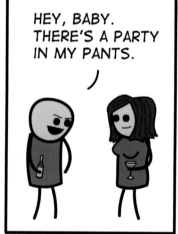

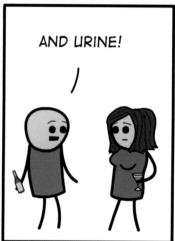

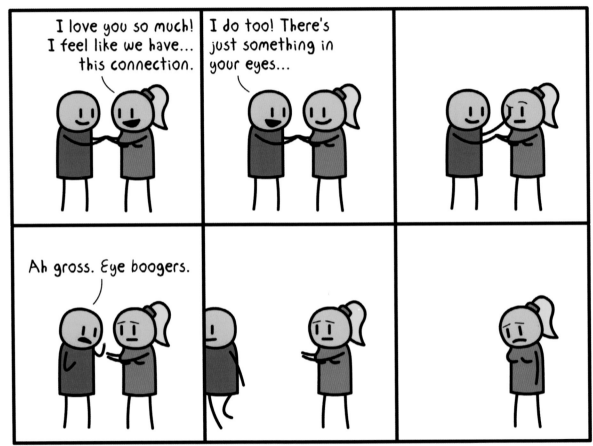

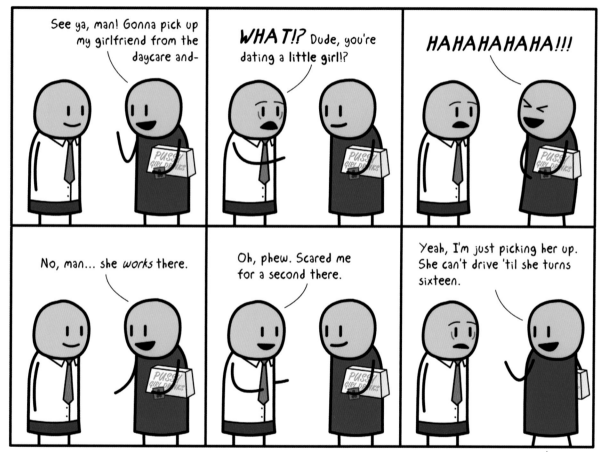

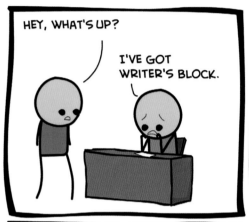

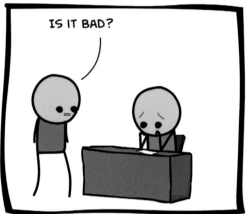

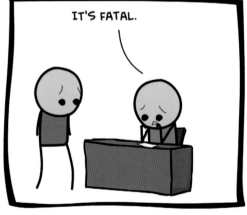

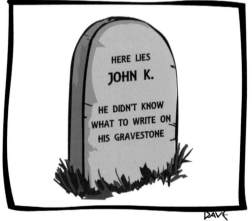

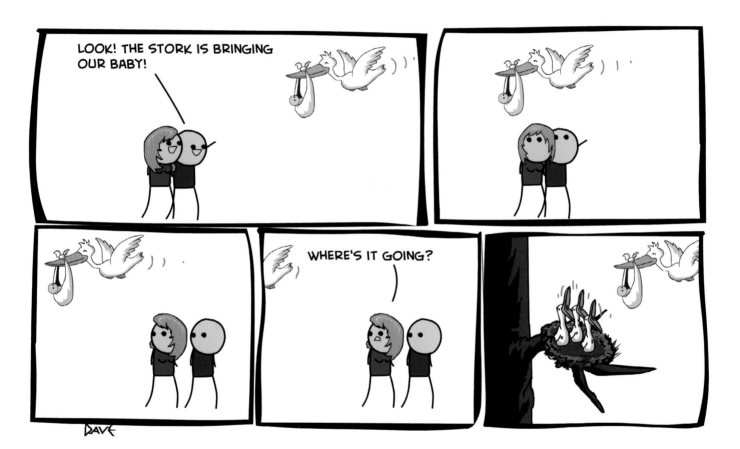

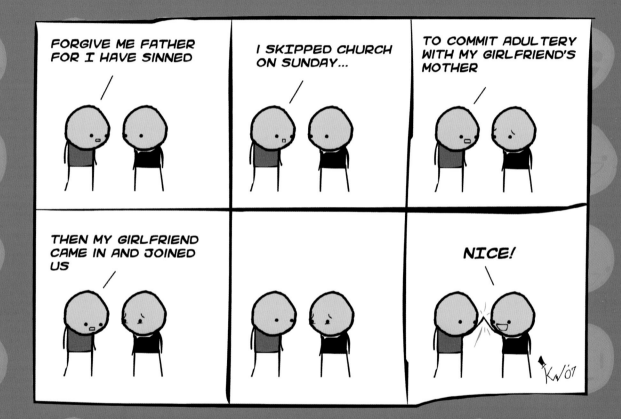

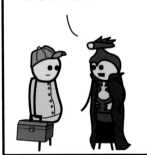

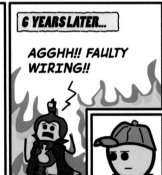

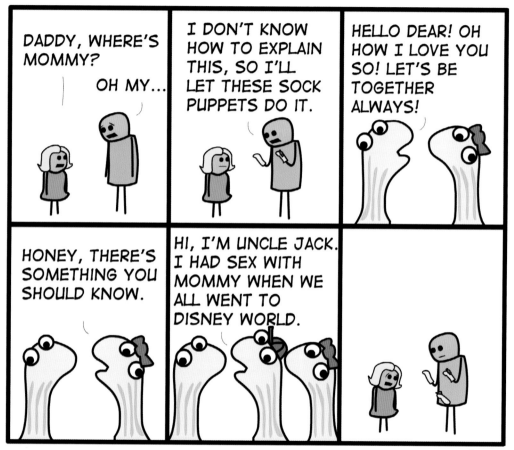

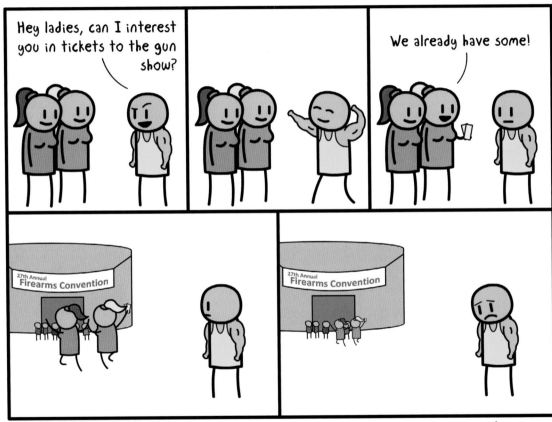

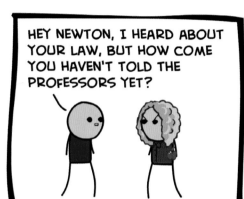

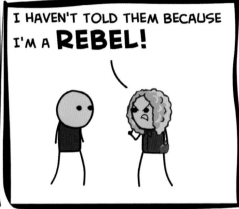

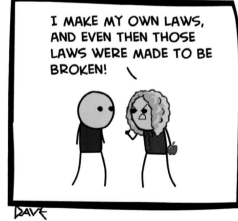

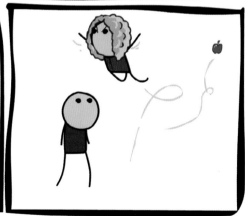

ANNIE, I WANT YOU TO KNOW THAT I ADORE YOU, AND I WILL TREAT YOU LIKE A QUEEN ALL YOUR LIFE. I LOVE YOU SO MUCH.

OH HEY, AN OLD LADY.

HAHAHAHAHAHAHA HAHAHAHAHAHAHA!!

SO ANYWAY, LIKE I WAS SAYING

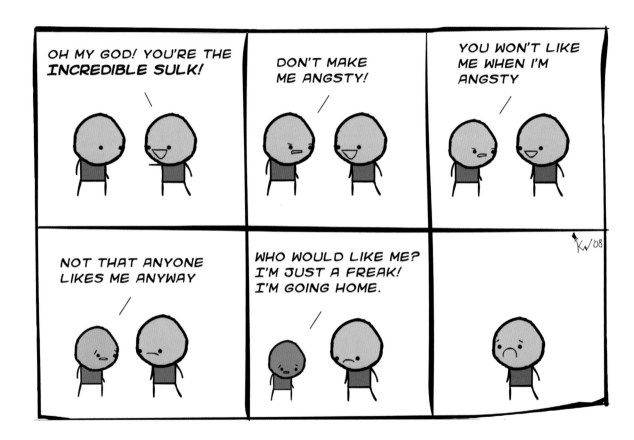

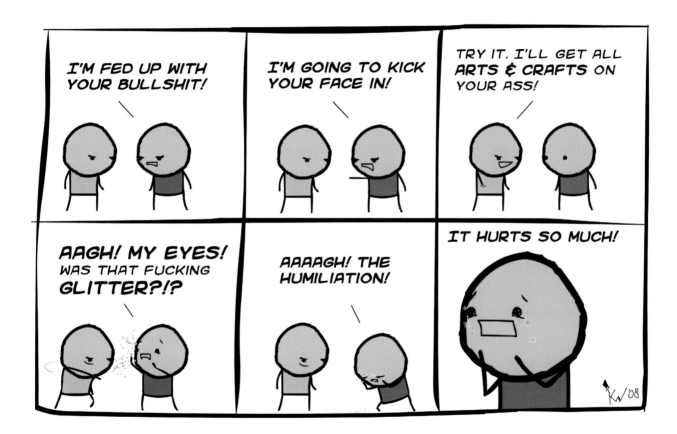

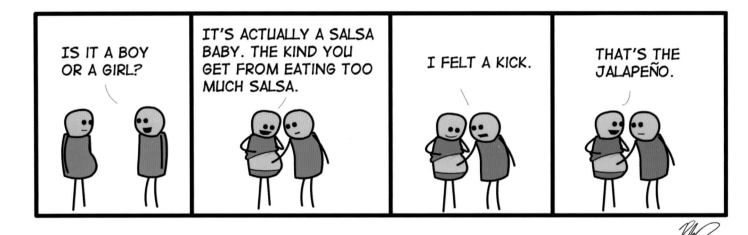

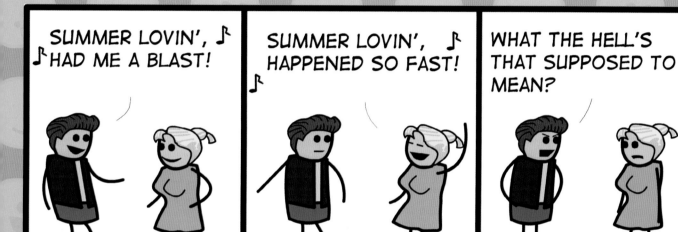

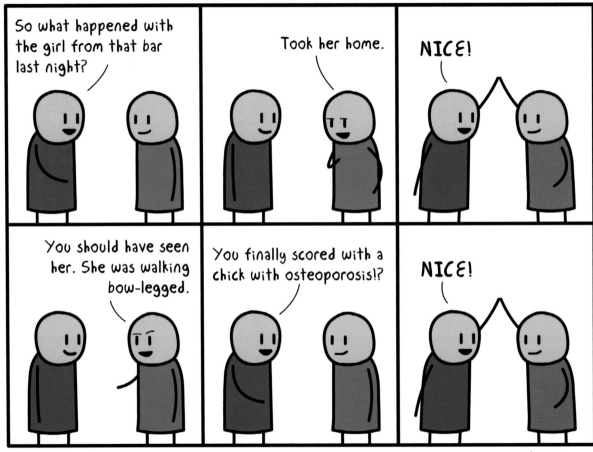

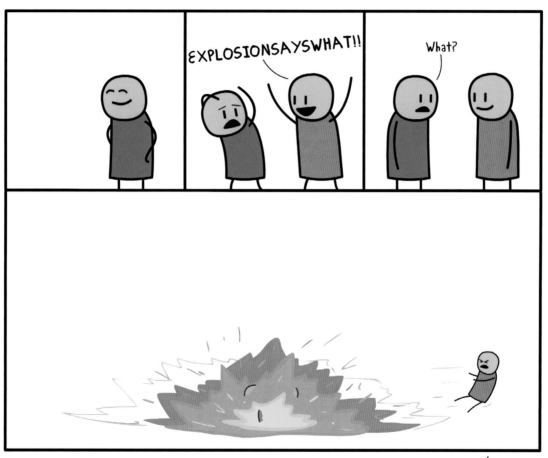

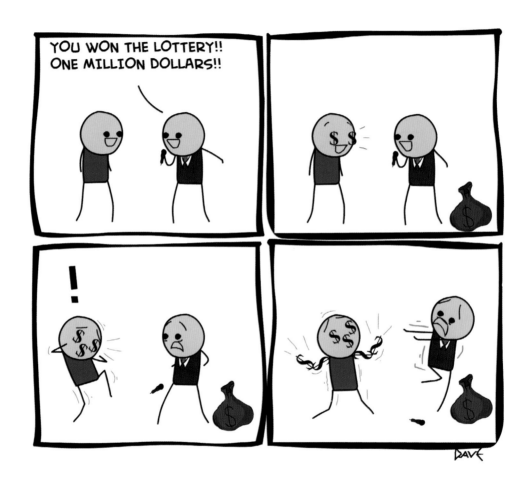

IN AN EFFORT TO RAISE AWARENESS FOR THIS TERRIBLE DISABILITY, WE'VE WRITTEN A COMIC TO ACCOMMODATE THE DEAF.

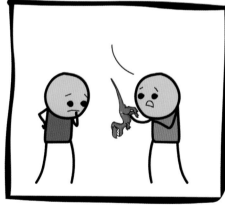

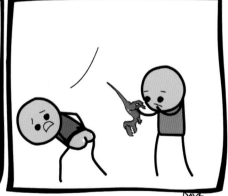

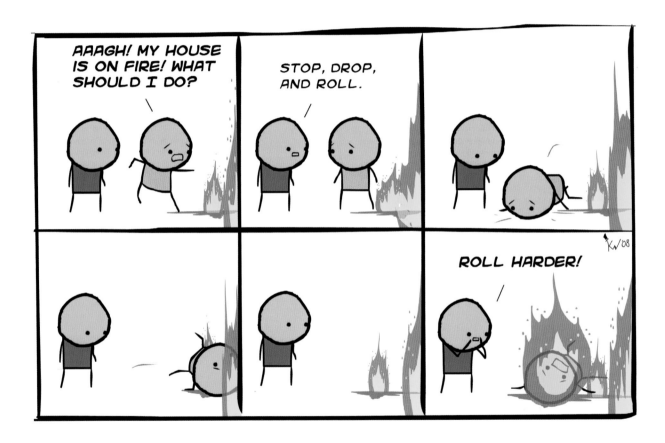

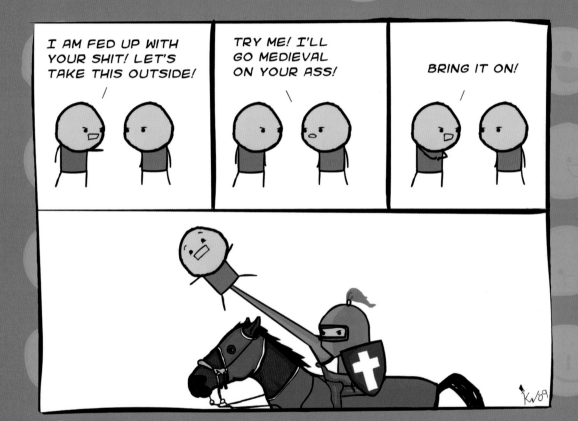

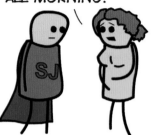 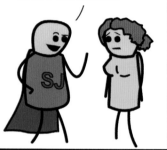 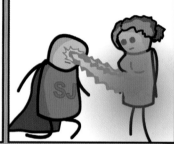

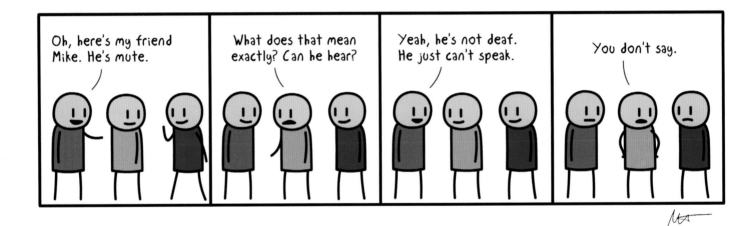

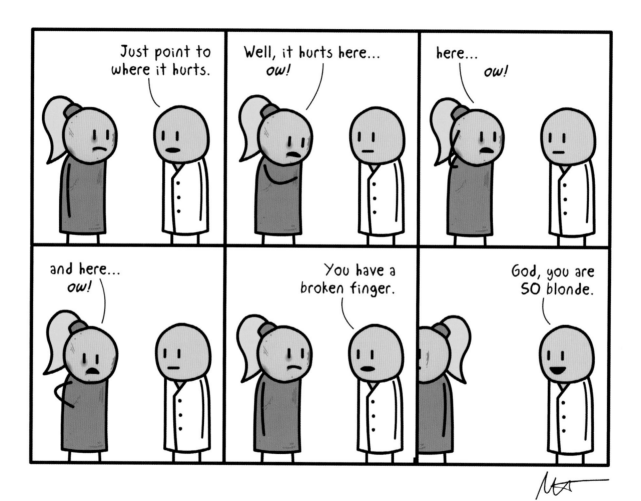

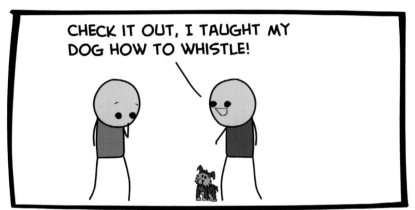

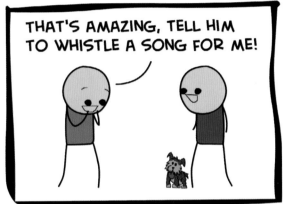

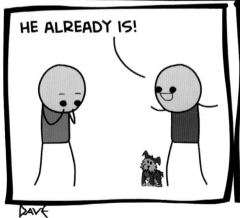

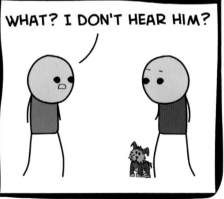

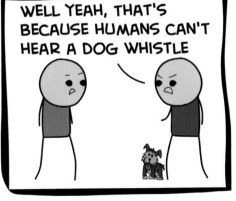

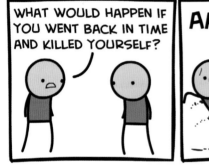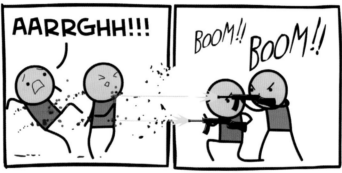

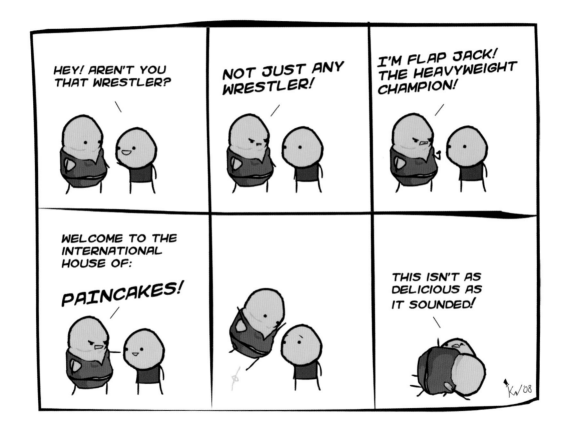

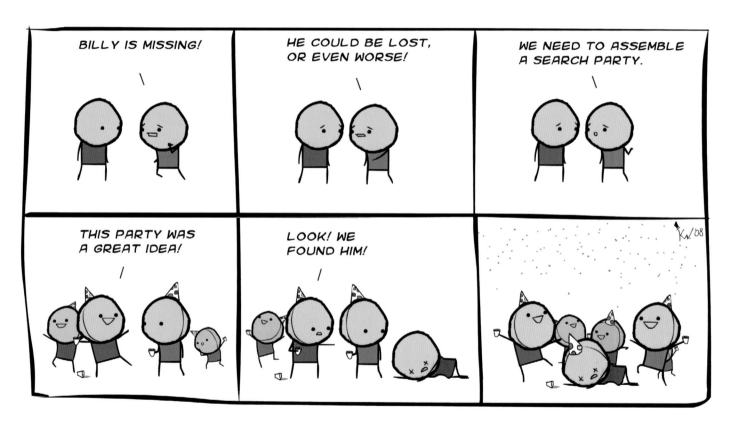

119

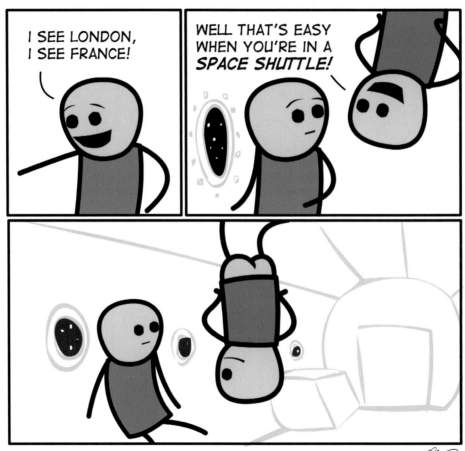

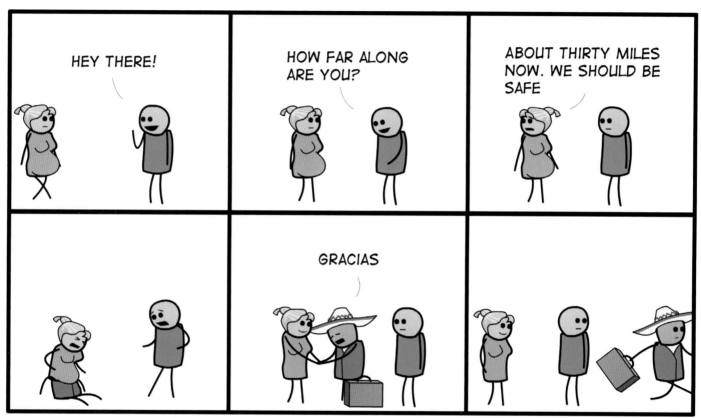

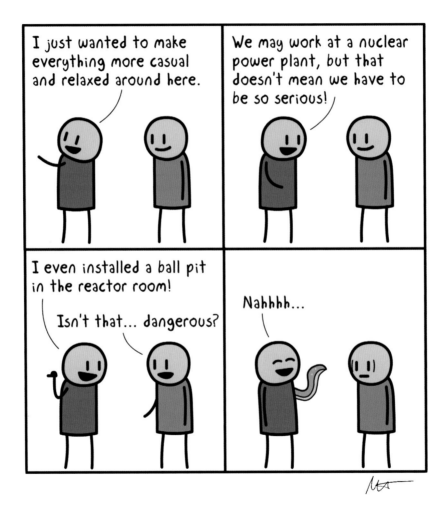

Furries:

The only people who take the birds and the bees metaphor literally.

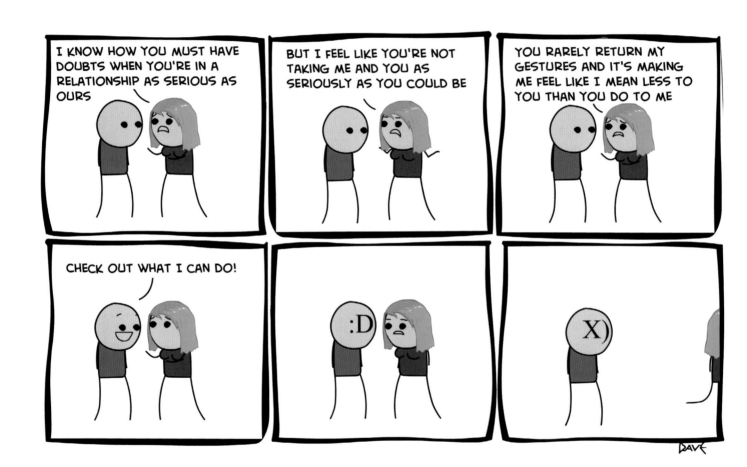

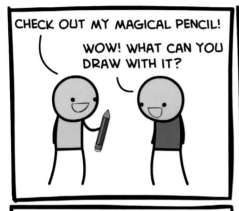

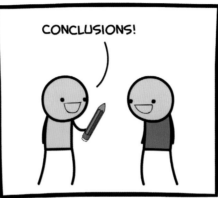

THE NEW ONES!
30 BRAND NEW, NEVER-BEFORE-SEEN COMICS

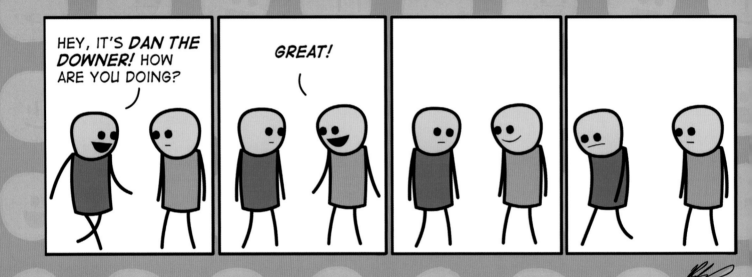

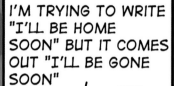
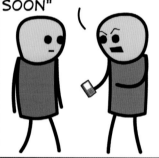
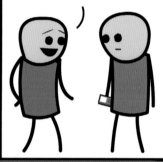
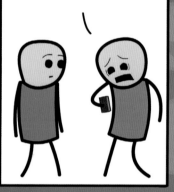

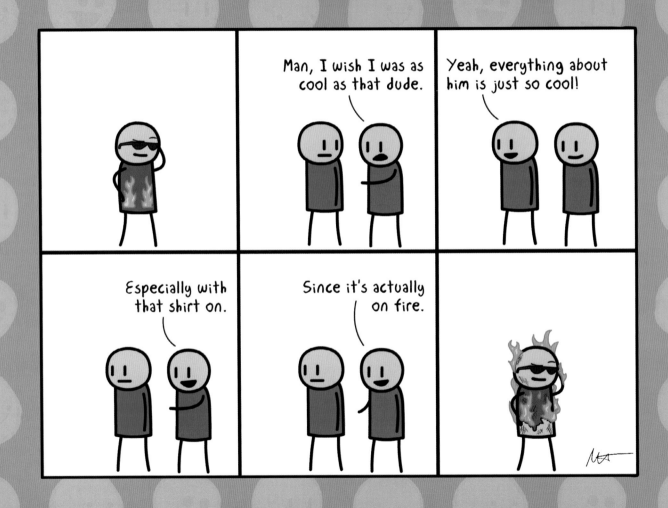

Extreme Sports Christ Part 3

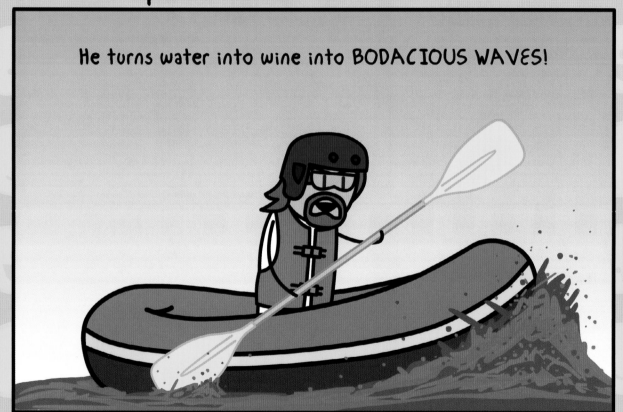

He turns water into wine into BODACIOUS WAVES!

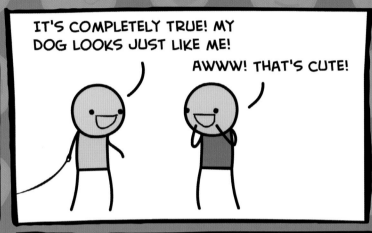

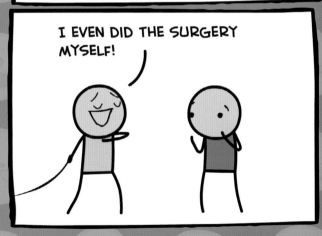

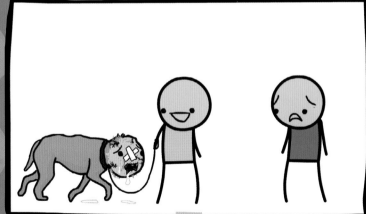

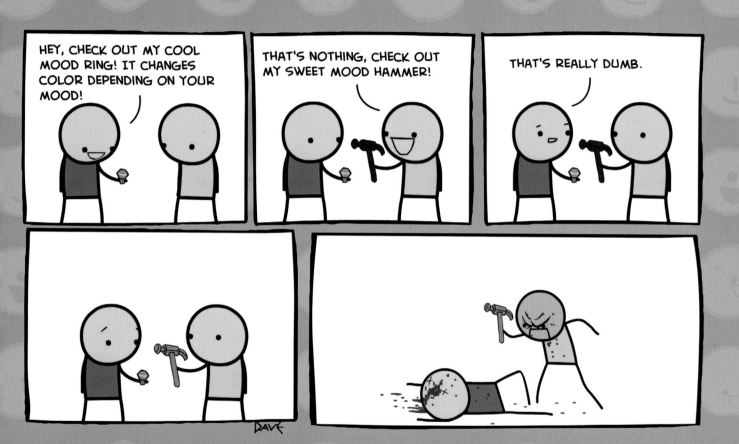

133

THIS TOWN AIN'T BIG ENOUGH FOR THE TWO OF US...

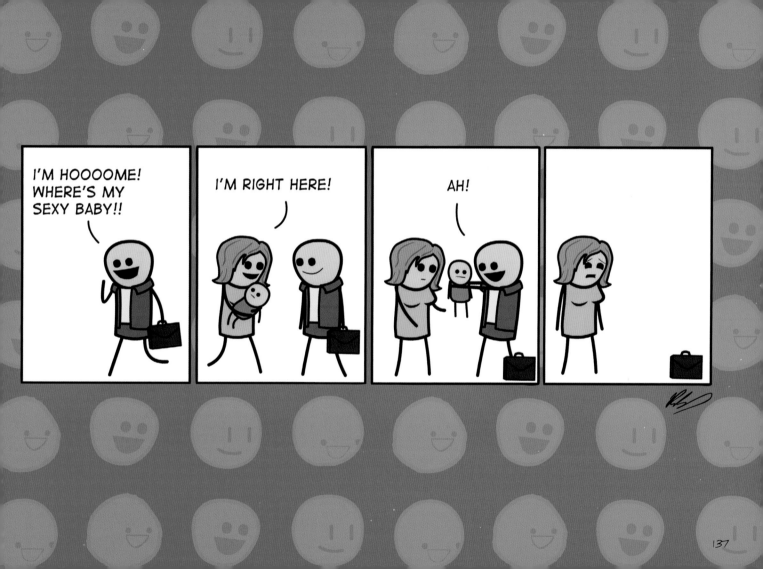

137

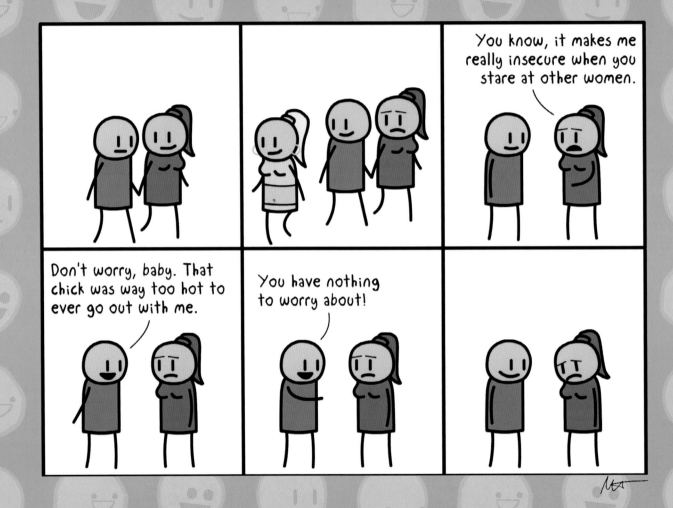

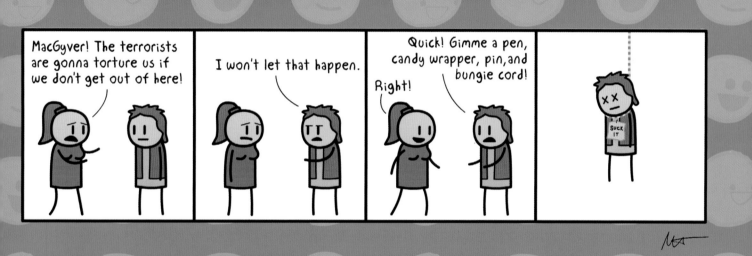

139

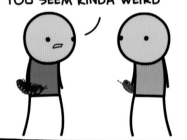

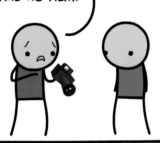 I NEED TO TAKE SOME PROFESSIONAL PHOTOS OF MYSELF, BUT ALL I HAVE IS THIS OLD CAMERA AND NO FILM.

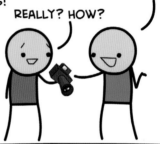 DON'T WORRY, THAT'S ALL YOU NEED TO GET SOME REALLY GREAT LOOKING PHOTOS!

REALLY? HOW?

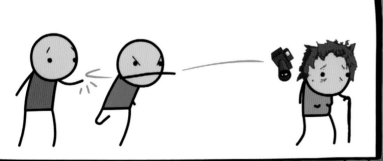

DAVE

2610200906

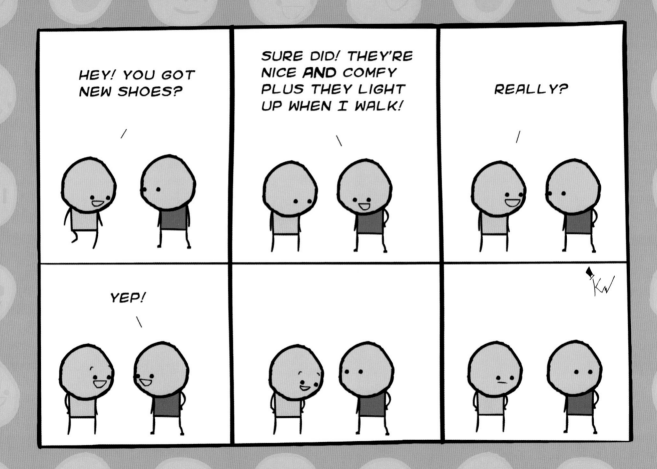

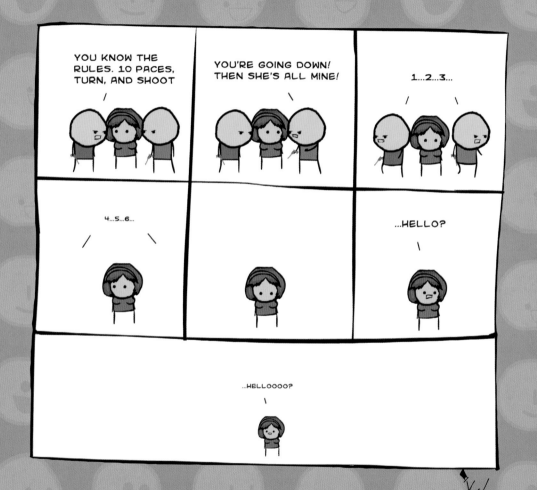

SHE SELLS SEASHELLS ON THE SEASHORE

SHELLS $1

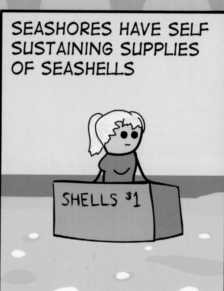

SEASHORES HAVE SELF SUSTAINING SUPPLIES OF SEASHELLS

SHELLS $1

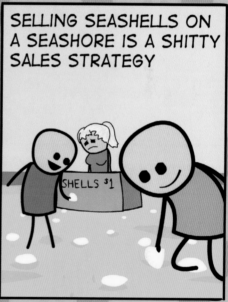

SELLING SEASHELLS ON A SEASHORE IS A SHITTY SALES STRATEGY

SHELLS $1

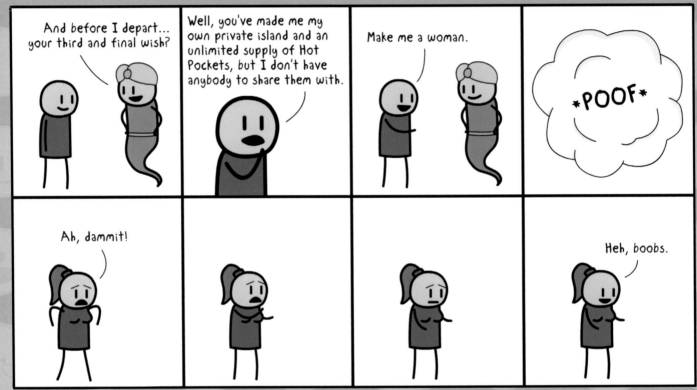

Extreme Makeover Christ

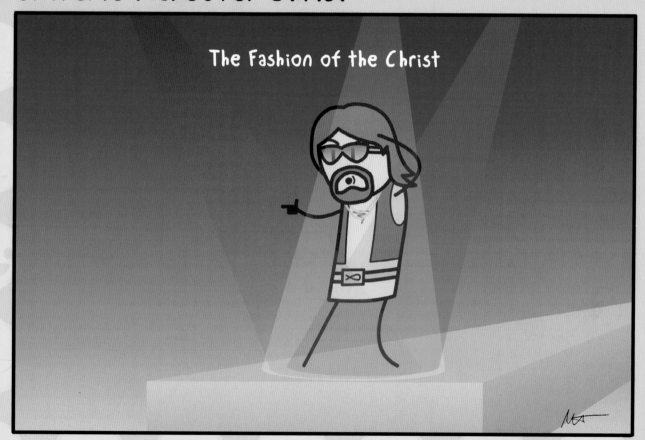

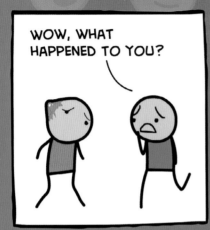

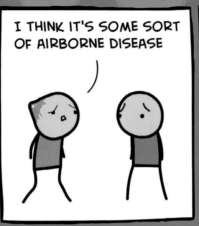

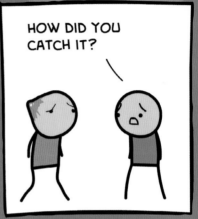

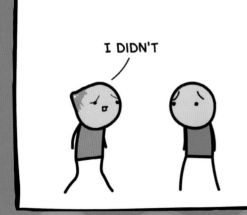

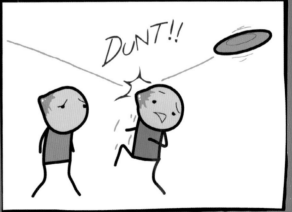

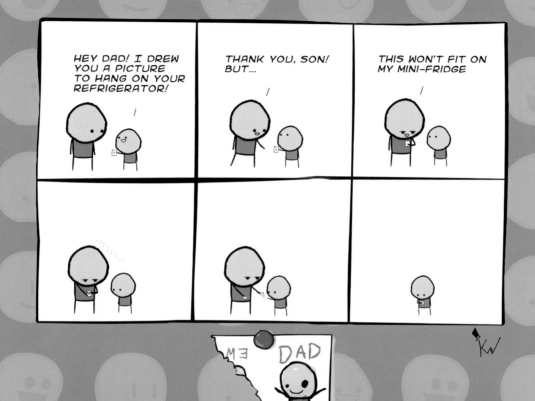

149

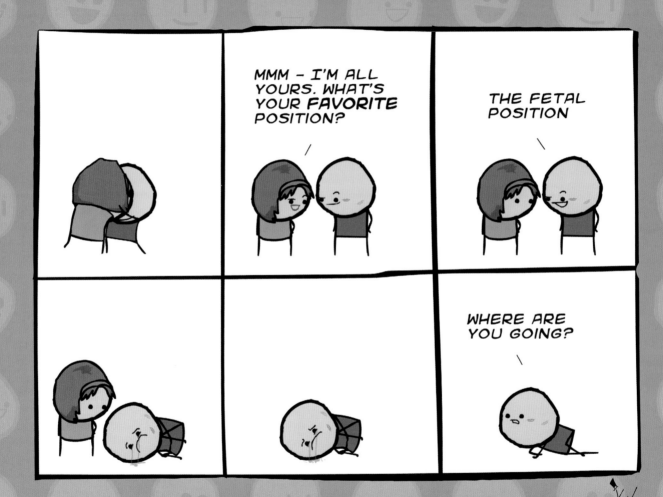

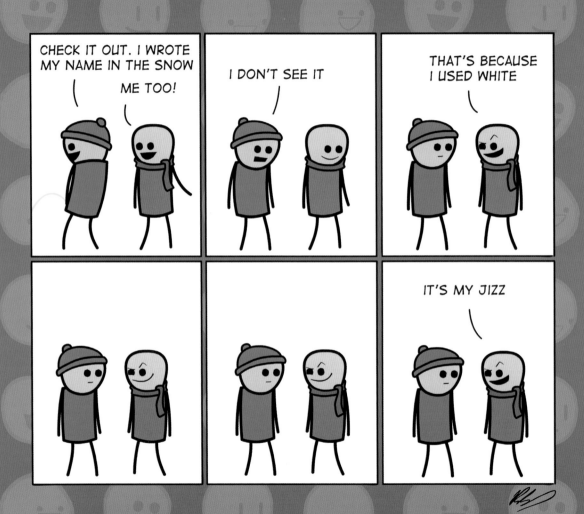

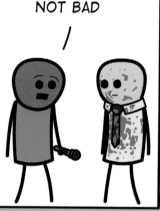

153

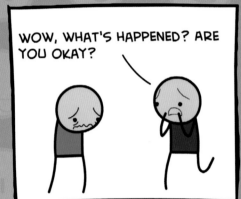

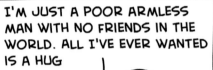

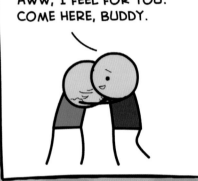

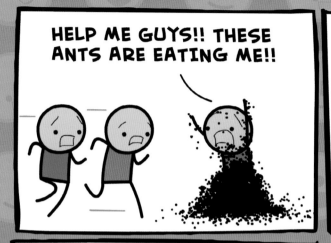

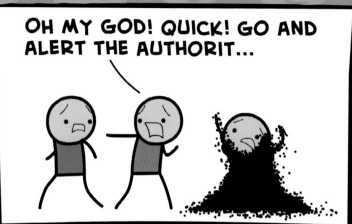

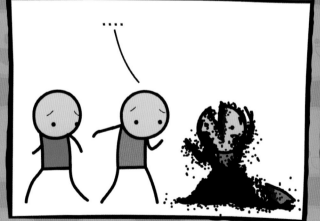

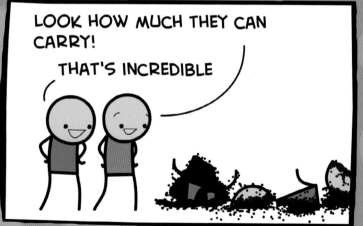

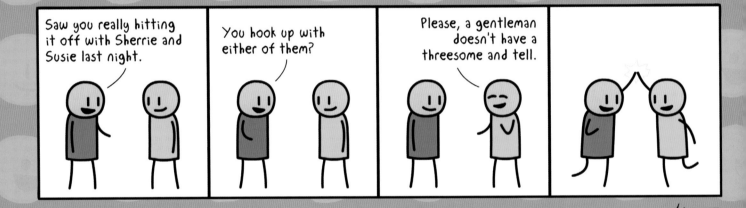

SO, LITTLE TOMMY, WHAT DO YOU WANT TO DO WHEN YOU GROW UP?

WHEN I GROW UP, I WANT TO ATTACK TOKYO

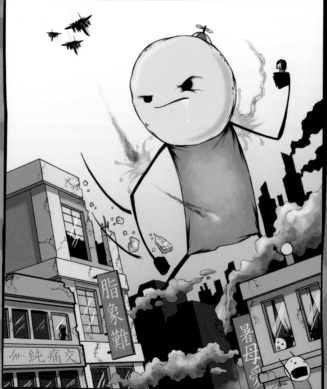

Special Thanks To Shawn Coss

BUST A THINKING CAP IN YOUR ASS, BECAUSE IT'S TIME FOR SOME

INTERACTIVITIES!!

GET YOUR PENCIL READY!

CONNECT THE DOTS TO REVEAL THE
HIDDEN IMAGE!

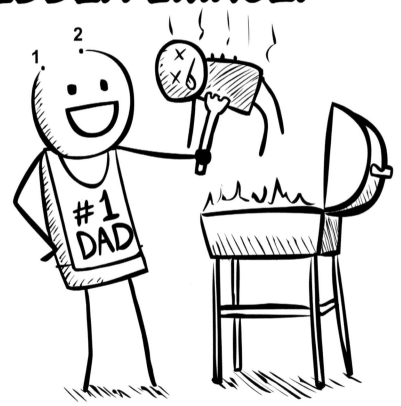

'MAZING

YOU'RE A SPERM SHOT OUT TO WANDER THIS WONDERFUL WORLD OF WONDER! START AT THE GREEN ARROW AND SEE WHERE YOU END UP!

START! ➡

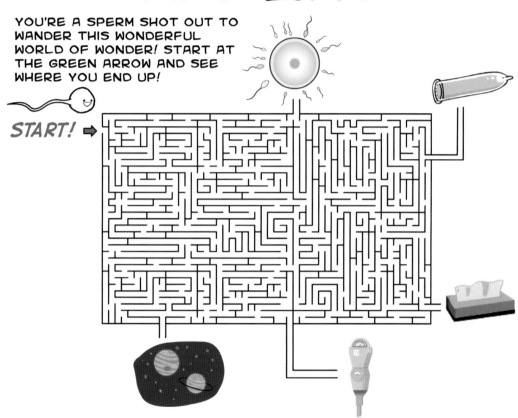

WROD SRCAMBEL!

1. **PNEIS**

2. **HTIELR**

3. **NGGERI**

4. **BUTTSXE**

SPOT THE DIFFERENCE!

You're racist. There is a bird missing from the right picture.

A SECRET MESSAGE?

Hold this to a mirror to reveal the secret message:

Turn your head upside down to reveal the real secret message:

You've been reading this backwards.

Crossword Puzzle

Across

1. Bananas in _____ are coming down the stairs
2. _____ in pajamas are coming down in pairs
3. Unpeels an outer layer to reveal the treat inside

Down

1. Cover with whipped cream for a late night treat
2. You might slip into these when it's dark
3. A smooth exterior hides the bruises

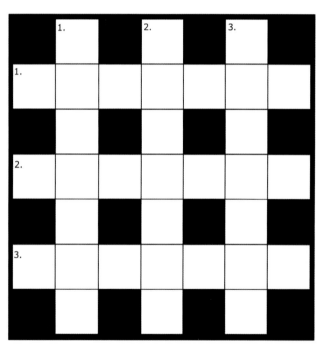

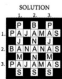

SOLUTION

COLOR BY NUMBERS!

1	2	3	4	5	6	7	8	9	10	11	12
13	14	15	16	17	18	19	20	21	22	23	24

WOOOORD FIIIIND!!

```
D N A Z I T F Q X S W Q R
A M N S T U U J D O P Q I
I S O E W R C F L S W P M
S D C A H N K L D A F P J
Y R A A S I I N 8 M I M O
M E B I N P N Q X A S S B
A D D X G A O E R E T I S
B R P O O P D W Q P I C S
H U G S K S A A W A N A I
```

DAISY
HUGS
BUBBLES
8
TURNIP
BACON
PILLOW

Draw your own CYANIDE & HAPPINESS character!*

Step 1:
Sketch head, using perspective lines.

Step 2:
Roughly plot out ribcage, pelvis, spine and limbs.

Step 3:
Outline head, torso. Add limbs and face.

Step 4:
Do some other stuff. Good job.

*Do not actually draw your own Cyanide & Happiness character, as this constitutes trademark infringement and will be prosecuted to the fullest extent of the law.

BUILD-A-BONER

1. CUT OUT THE CIRCLE

2. POKE YOUR FINGER THROUGH FROM THE BACK OF THE PAGE

3. SHOW YOUR GRANDMA

FURIOUS-LIBS

I KILLED HER. SHE TRIED TO _____ AWAY, BUT I RAN HER DOWN WITH MY _____.
 (VERB) (NOUN)

SHE WAS STILL ALIVE SO I _____ HER UNTIL SHE STOPPED _____ING.
 (PAST TENSE VERB) (VERB)

I DON'T REGRET IT. THAT _____ HAD IT COMING. SHE'D BEEN _____ING WITH
 (DEROGATORY SEXIST TERM) (VERB)

MY _____ FOR THE LAST _____ YEARS.
 (FAMILY MEMBER) (NUMBER)

HER BODY IS BURIED UNDER THE BIG _____ DOWNTOWN, BUT YOU'LL FIND HER
 (NOUN)

_____ BY THE OLD _____ FACTORY FIVE MILES WEST OF HERE. AS FOR ME,
(BODY PART) (NOUN)

BY THE TIME YOU'RE READING THIS I'LL BE HALFWAY TO _____.
 (COUNTRY)

 SINCERELY,

 (20TH CENTURY U.S. PRESIDENT)

ABOUT THE COMICS

Cyanide & Happiness

From Wikipedia, the free encyclopedia that anyone can edit
(redirected from Explosm)

Cyanide & Happiness began as a webcomic created by four guys in January 2005. Kris started it all by making a handful of funny stick figure comics at the age of 16 and was soon joined by Rob, Matt and Dave in an effort to keep it going as a daily strip.[1] Today, the comic is enjoyed by a worldwide audience numbering in the billions,[citation needed] that number growing every day. The comic has since been expanded to include occasional animated shorts.[2] They are awesome.[citation needed]

The four live in different places all around the world: Kris in Colorado, Rob in Texas, Matt in California and Dave in Ireland.[3] They work together almost solely via the internet and telekinesis.[citation needed] They are often compared to modern day versions of Renaissance artist Michelangelo.[citation needed] He was also awesome.[citation needed]

When they're not working on the comics, the four authors BALLS BALLS BALLS BALLS BALLS BALLS BALLS BALLS BALLS BALLS BALLS ASS 8==========D [citation needed]

KRIS

Kris Wilson is a nimble creature, entertaining himself in his natural habitat of Fort Bridger, Wyoming. Growing up in a small town, Kris drew constantly to avoid neurologically damaging boredom. He began drawing Cyanide & Happiness comics at the ripe young age of 16. These early strips were shared with the other dudes and together they developed Cyanide & Happiness into what it is today.

Kris's mild-mannered alter ego enjoys making music, illustrating, painting, swearing, cartwheels, and arson. If you ever see him around, give him all your stuff.

ROB

Rob DenBleyker, the best kisser of the four, hails all the way from Dallas, TX. It's not quite in the heart of Texas, it's more like the left collarbone location-wise. Texas' left, not yours. Rob writes/draws for Cyanide & Happiness, but originally started out doing animation. He still dabbles in it from time to time to help produce animated shorts at Explosm.net.

He joined the Cyanide & Happiness crew just after Kris did, in 2005. He plays cello, piano and people for fools.

MATT

Matt Melvin is a 26-year-old t-shirt aficionado and sideburn enthusiast. When not adding even more filth to the internet, he enjoys criticizing and complaining about movies, listening to music and inventing obscure types of niche sexual acts.

With his graphic design degree in hand, he designed Explosm from the ground up. Thank god that comic thing took off, though. Graphic design is boring as hell. It does have some positive aspects, though. His vast knowledge of the graphic arts obviously lends itself to the rich and deeply detailed stick figures he draws in the comics.

He recently published his first book, DRACULA IS A RACIST: A Totally Factual Guide to Vampires, a mock informative guide to the wide world of vampires. If you've ever wondered how vampires do their hair without any reflections or whether Sesame Street was ever truly safe from The Count, this is the 100% bona fide totally real and not made up at all truth you've been looking for.

He also recently launched a new site called RobotsWithFeelings.com, a collection of wonderful things. It's part blog, part comic and a quarter Cherokee on its mother's side. He draws comics, reviews movies he hasn't seen and imagines what would happen if all the US Presidents were faced against each other in a bracket-style tournament to see who could beat up all the others.

Matt currently lives in San Diego. He is very tall.

DAVE

Dave McElfatrick is the second oldest of the Explosm team, and therefore statistically the second earliest to die. Dave, unlike the other Explosm guys, hails not from America but from the small town of Coleraine in Northern Ireland. As a result, he has a stupid accent and likes to drink copious amounts of beer. He is currently living in the fair city of Belfast, where he writes and draws for Cyanide & Happiness.

When not indulging his keen interest in animation and animated film (an interest evident in his work with the Cyanide & Happiness animated cartoons), Dave enjoys writing bad music, passing judgement on other bad music, playing guitar badly, illustrating badly, and taking in the local scenery (badly). It's usually quite blurry from the night before. He has two little dogs. They're really cute.